LINLITHGOW
THROUGH TIME
Bruce Jamieson

AMBERLEY PUBLISHING

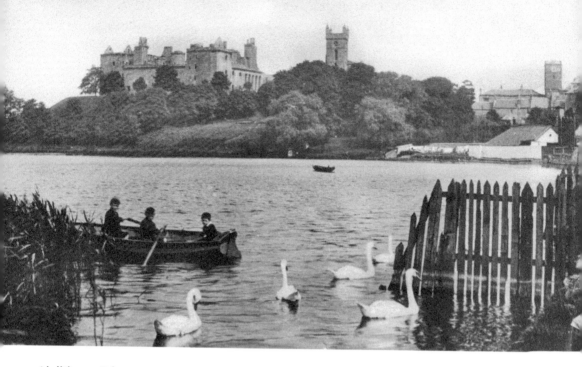

Linlithgow Palace

First published 2014

Amberley Publishing
The Hill, Stroud, Gloucestershire, GL5 4EP
www.amberley-books.com

Copyright © Bruce Jamieson, 2014

The right of Bruce Jamieson to be identified as the
Author of this work has been asserted in accordance with
the Copyrights, Designs and Patents Act 1988.

ISBN 978 1 4456 3622 1 (print)
ISBN 978 1 4456 3650 4 (ebook)

British Library Cataloguing in Publication Data.
A catalogue record for this book is available from the
British Library.

Typesetting by Amberley Publishing.
Printed in Great Britain.

Introduction

The origins of the town of Linlithgow go back to Roman times. Evidence has been found of a Roman camp in the area, connected to the Antonine Wall. However, it was the construction of a royal dwelling on a headland beside the loch that brought the town into greater prominence. The early wooden manor house of King David I was later garrisoned by the English, who invaded Scotland in 1301. King Edward, the Hammer of the Scots, camped on Linlithgow Peel (the area around the palisade) and left a troop of soldiers in the fortress. The castle was eventually stormed and returned to the control of King Robert the Bruce.

In 1424, a great fire swept through the town, and out of the ruins there arose a new, stone-built palace with a cluster of medieval cottages around it, housing a small population of farmers and craftsmen. By 1368, Linlithgow was appointed a member of the Court of the Four Burghs and thus one of the most important towns in Scotland. In 1389, King Robert II granted the burgh its royal charter, allowing the town authorities to hold weekly markets, charge fees for the use of Blackness Harbour and collect tolls at the entries to the town: the Low Port, the East High Port and the West Port. Every June, the town, led by an elected provost of the Court of the Deacons, remembers its ancient privileges by ceremonially parading around its boundaries during the traditional Riding of the Marches.

Within the increasingly enlarged royal palace there lived the dynasty of Stuart monarchs. King James IV made it his principal residence, and in the adjoining St Michael's church he was warned by a 'ghost' not to go to war against an English army. The King ignored the warning and was killed at the Battle of Flodden. King James V was born in the building in 1512, as was, in 1542, the ill-fated Mary, Queen of Scots. As a Roman Catholic monarch, she was caught up in the upheaval caused by the Reformation, which saw the ancient church of St Michael attacked and ransacked by the Protestant Lords.

The last king to spend the night in the palace was King Charles I, sixteen years before he was beheaded during the Civil War. Gen. Monck and his Roundhead soldiers arrived in Linlithgow in 1650 and, in order to improve their defences, the Cromwellian troops demolished many of the old buildings around the church and palace, including those in the Kirkgate and around 'The Cross', the centuries-old market place. Included in the destruction was the town hall (which

dated back to the fourteenth century) and the 'sang schule' that had trained the boy choristers of St Michael's. This school was the twelfth-century originator of many educational establishments in the burgh, including Linlithgow Academy.

The eighteenth century saw the gradual decline of the burgh's fortunes. Rival ports along the River Forth challenged Linlithgow's trading monopoly. In 1746, during the Jacobite Rebellion, the palace caught fire and was reduced to a ruin (albeit an impressive one) visited by Robert Burns.

By the mid-nineteenth century, Linlithgow was no longer in the forefront of Scottish towns, although a thriving leather-making trade and a collection of breweries and distilleries employed many inhabitants. The arrival of the Union Canal and, later, a railway line, linking the town to both Edinburgh and Glasgow, also helped to improve the town's commercial position.

The twentieth century witnessed the construction of an explosives factory, which, during both World Wars, produced ammunition for the British Army.

In more recent years, the town has developed into a commuter town and the population has risen rapidly from 5,000 in 1970 to almost 15,000 today. The town's five primary schools and its secondary establishment, Linlithgow Academy, are all very busy and the town groans under the weight of traffic and a narrow medieval street pattern. However, the residents of the burgh remember their proud history and traditions, and locals are proud to call themselves 'Black Bitches' after the royal hunting dog depicted on the town crest.

Acknowledgements

Most of the early illustrations are from my own collection. I am also grateful to Linlithgow Heritage Trust for their assistance. The modern photographs were taken by myself, Andrew West and Fraser Shiells. Grateful thanks go especially to Fraser for the 6.00 a.m. shots!

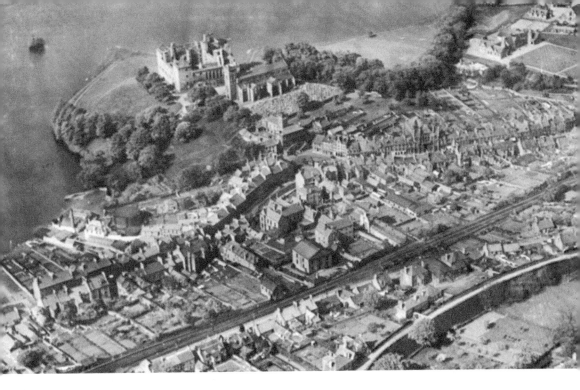

Aerial Views of Linlithgow

Linlithgow, or *Gleanna Lucha* as the Gaelic sign at the railway station proclaims, owes its name to the Brythonic name for a 'loch in a wet hollow', the loch being a remnant watercourse of the River Avon. In the 1960s, the old buildings at the centre of the town were demolished and replaced by concrete flats. Another 1960s addition to the skyline was the erection of a 'golden' spire atop St Michael's church, perched on its promontory beside Linlithgow Palace. To its right is the Peel, which takes its name from the fortified palisade of King Edward I.

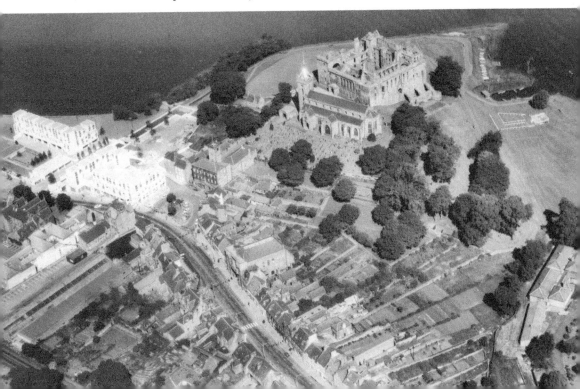

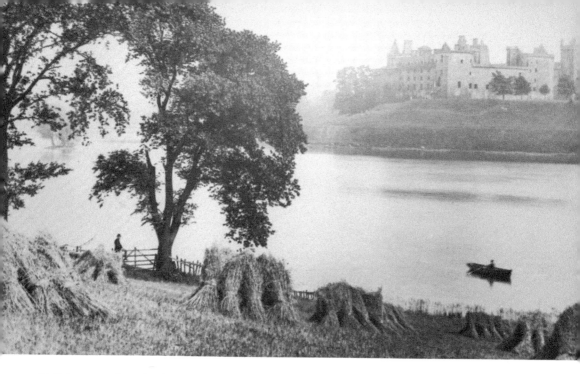

Linlithgow Loch and Palace

Linlithgow Palace is now a ruin – its internal structure destroyed by fire. The 1890 photograph was taken from the lands of Parkhead, then owned by the Crown as part of the Royal Hunting Reserve around the Palace – a principal residence of the Stuart monarchs and birthplace of James V and Mary, Queen of Scots. Parkhead Farm, now privately owned, no longer stretches to the lochside. A path around the loch, maintained along with the palace by Historic Scotland, has replaced the cornfield and stooks. The north-west corner of the building was where Mary Stuart was born in 1542.

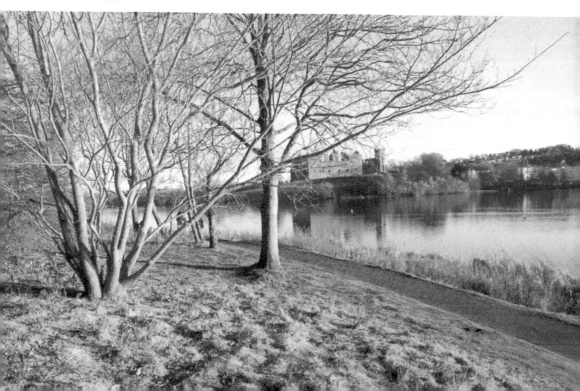

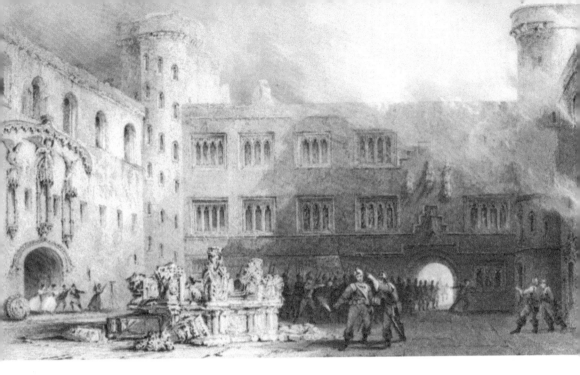

Linlithgow Palace Fire

On 1 February 1746, Government troops under the command of Lt-Gen. Henry Hawley were pursuing Jacobites in the vicinity. Hurriedly, they left their overnight camp in Linlithgow Palace and rushed out, leaving their campfires burning around the building. The ancient fabric ignited and the 320-year-old structure was badly damaged. The 1839 engraving depicts a group of women, led by the Keeper of the Palace, Mrs Glen Gordon, chastising the fleeing troops with the words 'A-weel, I can rin frae fire as fast as ony General in the King's army'. The well in the courtyard has recently been restored.

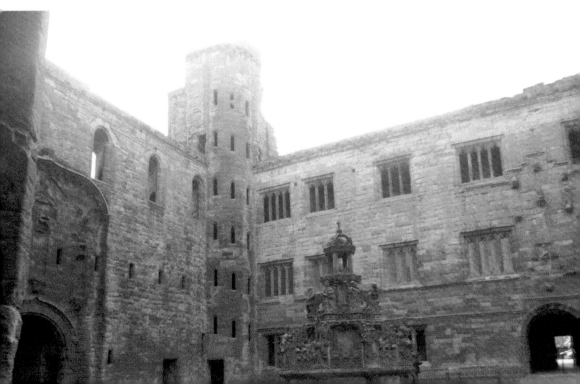

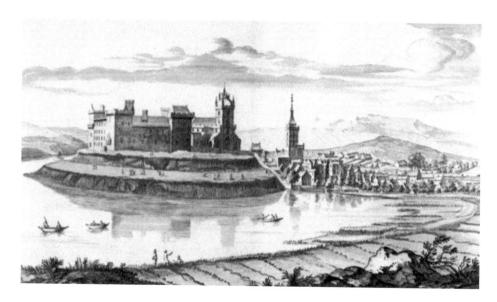

The Spires of Linlithgow

In the late seventeenth century, a Dutch-born surveyor, John Abraham Slezer, set about recording the principal castles and palaces in Scotland – a country he had lived in since moving there at the age of twenty in 1669. The results of his penmanship were published in 1693 under the title *Theatrum Scotiae*. The engraving of Linlithgow, made through the use of a camera obscura instrument, shows the still-roofed palace, the stone crown on St Michael's church and the pointed spire on the seventeenth-century town hall. All have now gone or been replaced.

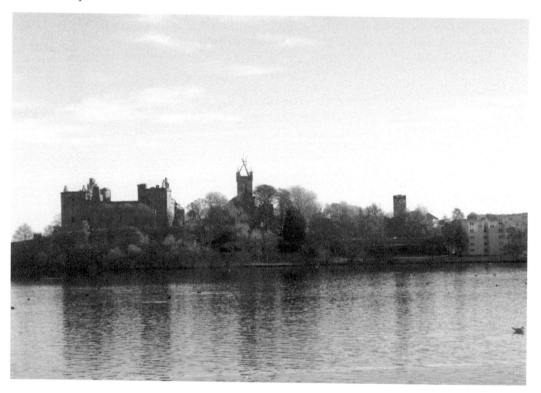

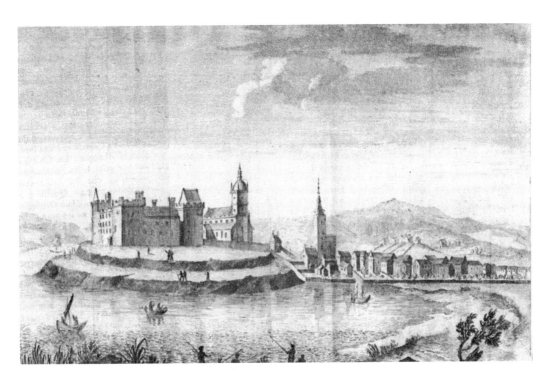

Fishing on the Loch

The engraving by Thomas Salmon was published in Italy under the title *Veduta del Palazzo Reale di Linlithgow*. Salmon accompanied Admiral Anson on his circumnavigation of the world (1740–44). On his return, Salmon set about recording important Scottish towns and captured Linlithgow Palace on its terraced mound with boats fishing and eel catching in the Royal Eel Ark. An eel spear found in the loch is now in the Palace Museum. Fishermen still frequent the waters of the loch, their boats administered by the Forth Area Federation of Anglers, which was established in 1958.

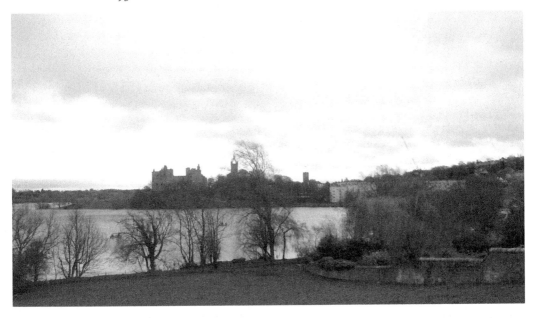

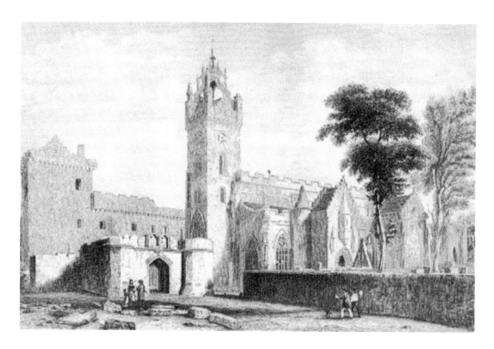

St Michael's Church

St Michael's church, consecrated by Bishop de Bernham in 1242, has suffered much throughout history: its Roman Catholic statues were destroyed by Protestant Reformers; its interior was used by Cromwellian troops as a stable; and its exterior walls were used for target practice. The original 'royal' crown was topped by a weathervane depicting a mother hen with her chickens and the inscription *non dormit qui custodiat* ('who guards does not sleep'), a Latin version of psalm 121, verse 3 and a favourite motto of King James III. The crown was removed in 1821 as it was causing problems with the stonework of the tower.

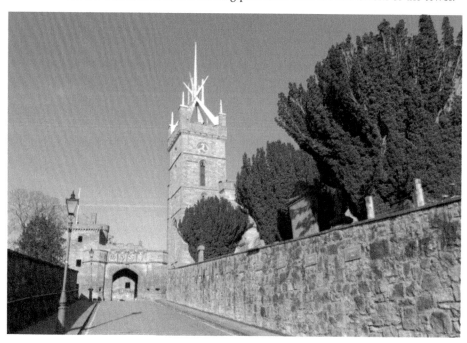

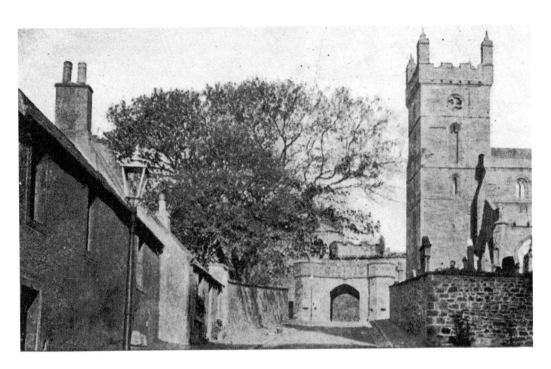

St Michael's Spire

The early twentieth-century postcard view above shows that the stone crown of St Michael's has been removed. A new spire was erected in 1964 – the work of sculptor Geoffrey Clarke, under the guidance of Sir Basil Spence. Constructed from lightweight, laminated timber, covered in gold, anodized aluminium, it depicts Christ rising above a twelve-pointed Crown of Thorns. Fairly contraversial at the time, its installation was championed by the Revd David Steel, who was minister of St Michael's church from 1959 to 1976.

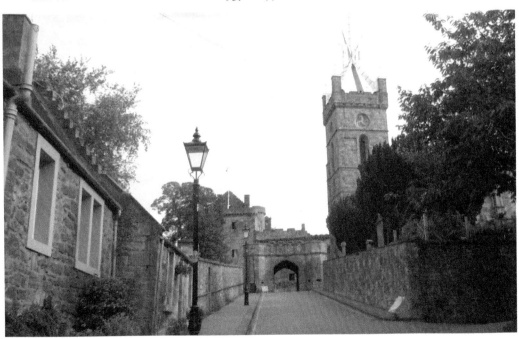

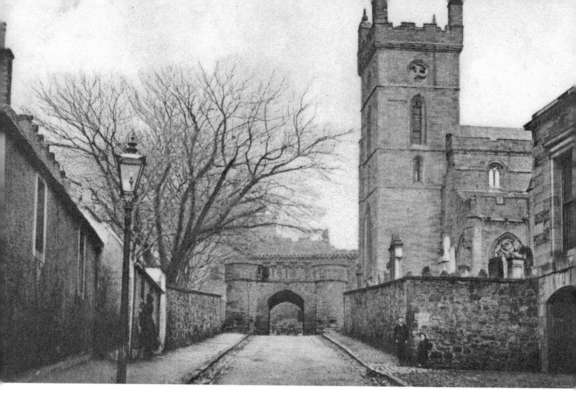

The Kirkgate

At the top of the Kirkgate is the nineteenth-century archway bearing the orders of chivalry granted to King James V: the Garter of England, the Thistle of Scotland, the Golden Fleece of Burgundy and St Michael of France. The orders have been painted in what we are assured are the original, bright, gilded colours. The lady in the old view stands at a doorway now leading to the new St Michael's Manse, built in 1974. The wall to the right now carries a line of plaques that show the line of royal descent from Mary Stuart to Queen Elizabeth.

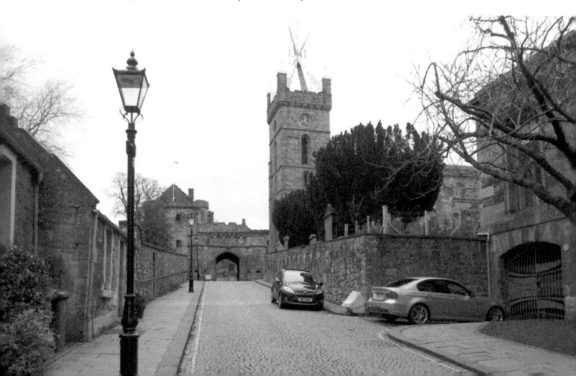

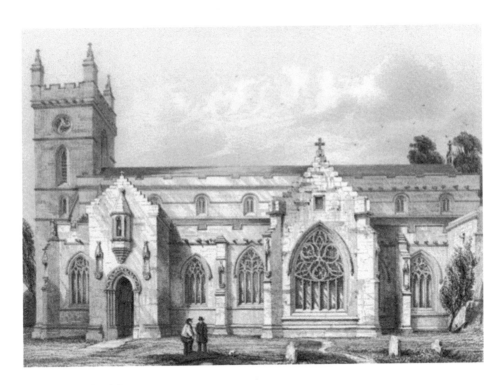

St Katherine's Aisle

The early nineteenth-century print above features the spire-less tower and the flamboyant window of St Katherine's Aisle, where King James IV was accosted by a 'ghost' warning him not to proceed to battle against an English Army. The monarch ignored the warning and was killed at the Battle of Flodden in September 1513. In 1992, on the church's 750th anniversary, new stained glass was installed in the window. It was created by Crear McCartney and designed around the theme of Pentecost. A golden spire now tops the tower in which hang three bells: Meg Duncan, Alma Maria and St Michael.

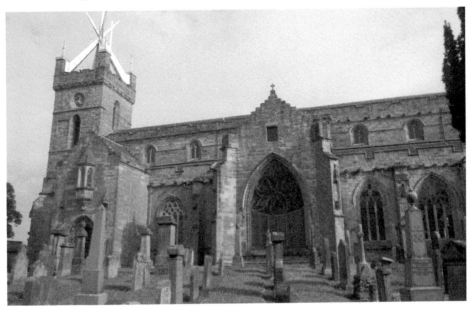

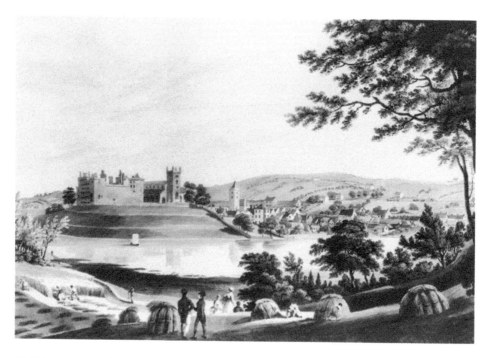

Linlithgow From the West

The 1824 drawing above by artist John Clark is part of the Government Art Collection and hangs in the Ministry of Justice, London. The gentlemen in the foreground are John Gibbeson (a wealthy Linlithgow leather and glue manufacturer) and Robert Bowie, a farmer, who leased Parkhead Farm from the Crown. Also visible is the spired town hall and the smoke stack of a canal boat on the Union Canal. The canal, finished in 1822, is still in operation but the town hall spire was destroyed by fire in 1847. Today, a path takes walkers around the loch through the fields where the men once met.

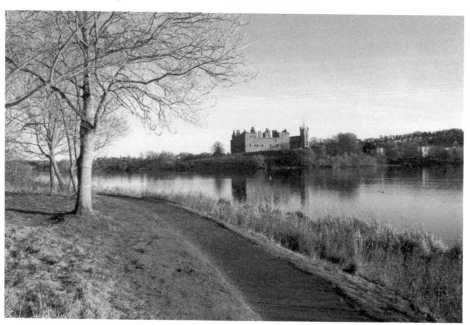

Linlithgow Peel

The original entrance to the Palace faced eastward. Above the drawbridge were the arms of King James I, for whom the earlier hunting lodge was rebuilt in the 1420s. Local legend states that the swans on the loch, being 'royal birds', left the town on the arrival of Cromwellian troops and did not return until the restoration of King Charles II in 1660. The area in front of the palace, the Peel, (somewhat enlarged with infilling) hosts many events such as jousting tournaments, dog shows, musical events, a Chanel fashion show and the annual Gala Day – and the swans are still there.

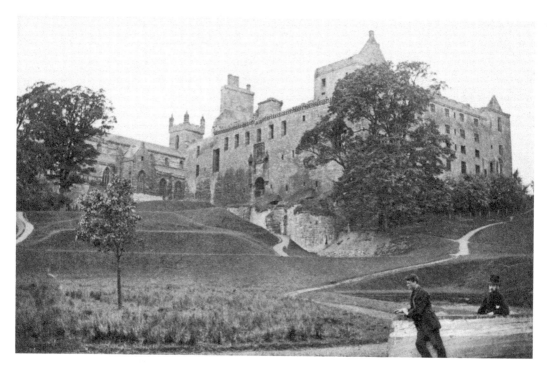

Royal Park 'Peelies'

On the loch, a small, still existent harbour once conveyed members of the ruling Stuart household on to a royal barge. Nowadays, it is used by the yachts and canoes of an outdoor centre and sailing club. The royal parkland was looked after by park keepers or 'Peelies', as they are locally called. The top-hatted gentleman Peelie, pictured above, has been replaced by park rangers and Historic Scotland employees. To the left is the north face of St Michael's church where, in the graveyard, lie former ministers, the Revds Dobie and Bell.

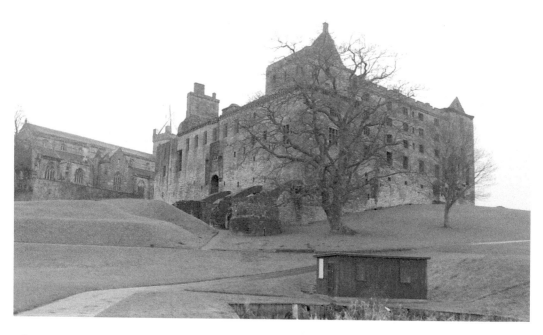

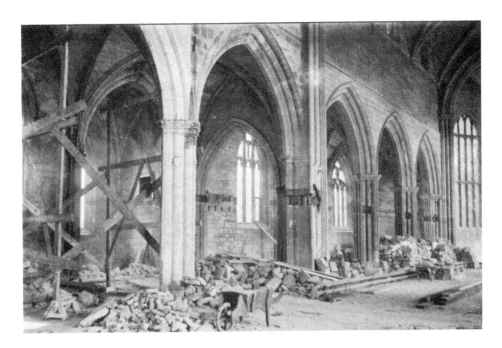

St Michael's Restoration

By the late nineteenth century, years of neglect necessitated a major restoration of the interior of St Michael's church. Under the guidance of the Revd John Ferguson, the old galleries were removed, holes filled and the nave cleaned of its whitewash. The floor was lifted and relaid at a lower level, exposing the base of the fifteenth-century pillars. The restoration cost £7,300 and the two years' work was completed in 1896. Today, the church is largely unchanged, save for the addition of a new ceiling, the result of a campaign in 1983 that raised the required £50,000.

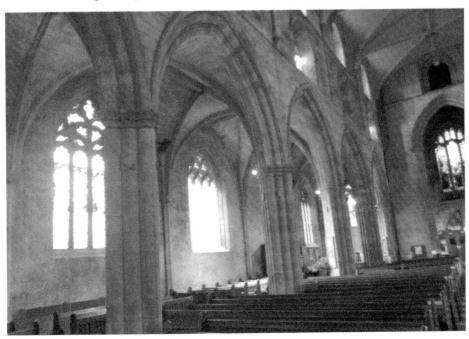

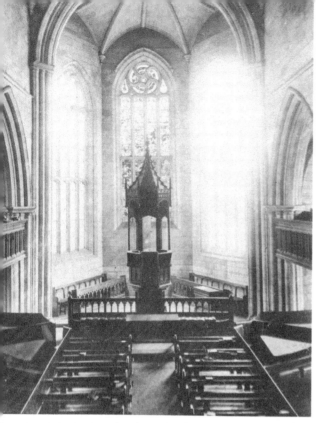

St Michael's Apse and Pulpit
The galleries, which were rented to trade organisations, are to the left of the 1812 Gothic pulpit. At the 1896 restoration, the pulpit was moved to the north side of the church, in front of the choir stalls, but in 2003 it was moved again to the south side of the chancel to make way for a new organ housing and toilet 'pod'. The large window was installed in 1885 in memory of the locally born oceanic explorer Charles Wyville Thomson, who was laid to rest in the north kirkyard in 1882.

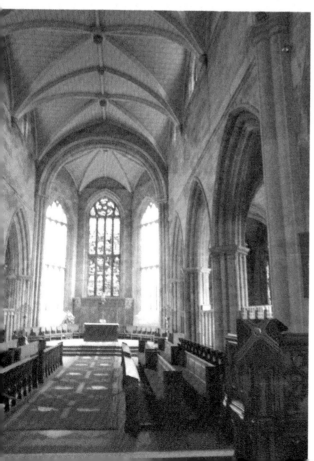

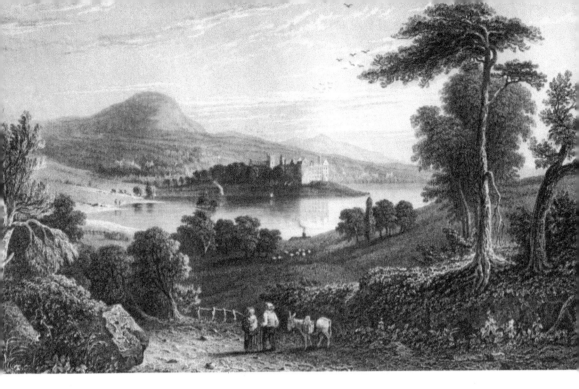

Linlithgow from the North East

The mid-nineteenth-century drawing by William Brown puts Linlithgow in its geographical context. The loch to the north and the steep hillside to the south restricted growth for many centuries. However, in the twentieth century, demand for housing resulted in much residential development around the town. The drawing rather exaggerates the prominence of the tallest hill, Cockleroy, in the Bathgate Hills. At its summit is a Bronze Age hill fort and nearby the Neolithic burial chamber of Cairnpapple. The white building in the modern view is Kinloch View – a residential retirement complex built in 2005.

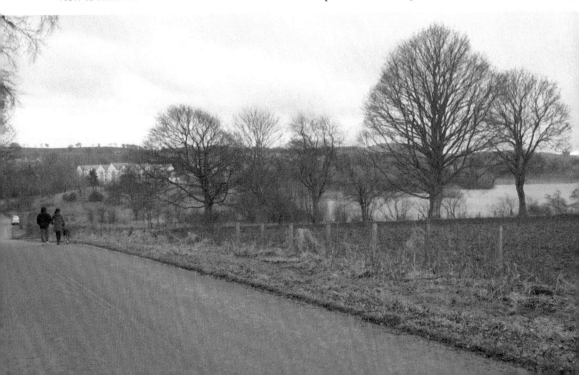

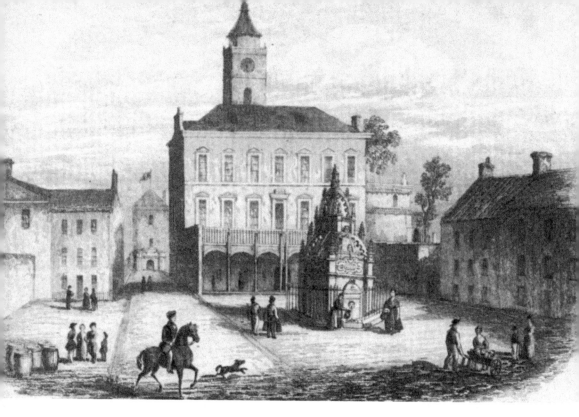

Linlithgow Cross

At the centre of Linlithgow life is The Cross. The early nineteenth-century sketch features the Burgh Halls – a replacement for the late fourteenth-century building demolished by Cromwellian troops. A 'new' one was built in 1668 to designs by John Mylne, master mason to King Charles II. Initially, it had a front staircase, but this was replaced in 1810 by an iron loggia called the Piazza – perhaps to provide shelter for market stalls. The pointed top of the tower was destroyed by fire in 1847. In 1906, the original staircase design was reinstated. The halls have recently received a £5.2-million facelift.

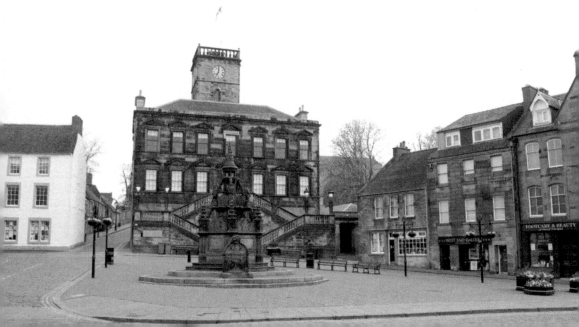

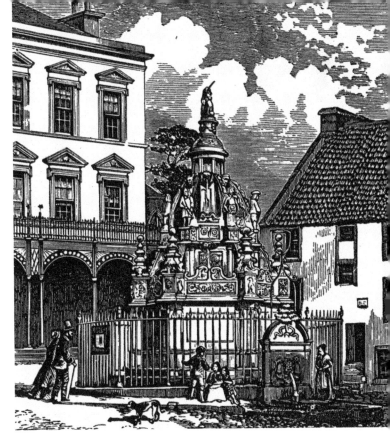

The Cross Well

In front of the town hall is the Cross Well – an early seventeenth-century replacement for an even earlier structure. In 1807, the elaborate, hexagonal creation was largely re-carved by Robert Gray, a one-handed stonemason who strapped his mallet to the stump of his left hand. The drawing was created for a local postcard series marketed by C. M. Spence, whose newsagent shop and printing works were just over the street from the well, in what is now The Four Marys restaurant. The house to the right of the well was later converted into a fire engine station and is now a coffee shop.

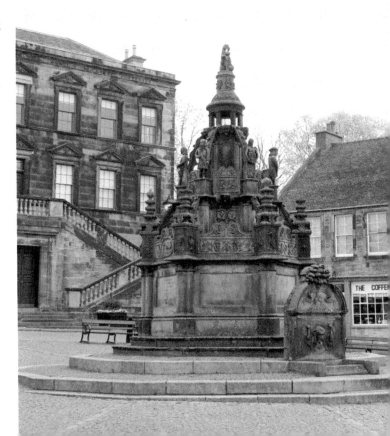

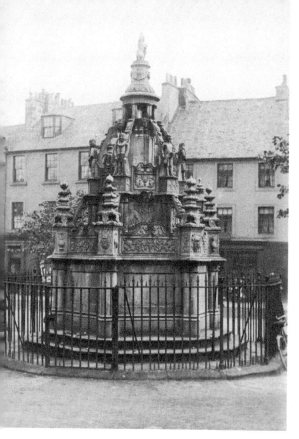

Cross Well Detail

Topping the Cross Well is the carved unicorn symbol of the Stuart royal dynasty. Other figures carved by one-handed Robert Gray include the town drummer, who still awakens the town early in the morning of the annual ceremony of the Riding of the Marches. Behind the well, in the 1880s photograph, is a group of interesting eighteenth-century buildings, which replaced earlier properties belonging to the Knights Templar. Some have been restored, including No. 79, which still bears its early nineteenth-century Sun Fire Insurance plaque, allowing the company's firemen to identify the property.

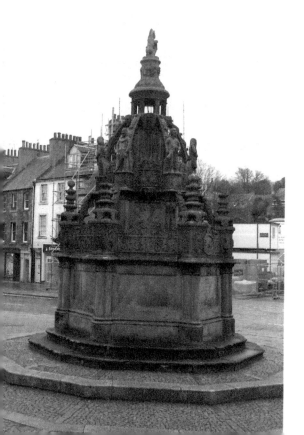

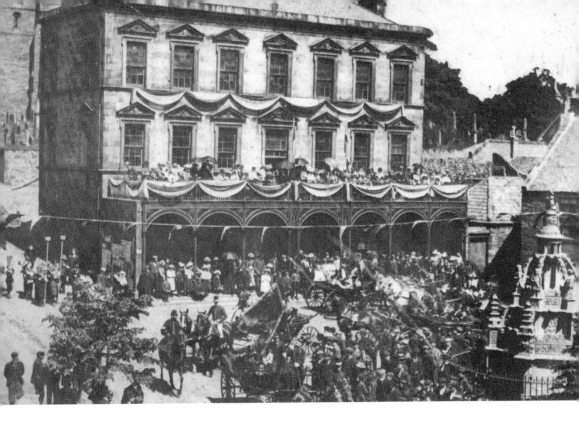

Linlithgow Marches Parade Leaves The Cross

In the 1890s Marches Day photograph, the town's dignitaries stand on a balcony above the decorated piazza. In the square below, the horse-drawn landaus are preparing to carry the civic dignitaries, the provost and bailies of the town council – to inspect the town's boundaries at Linlithgow Bridge and Blackness. This tradition, which can be traced back to the granting of a royal charter by King Robert II in 1389, continues to this day on the first Tuesday after the second Thursday in June. The marching, red-coated musicians are members of the Linlithgow Reed Band, which was founded in 1956.

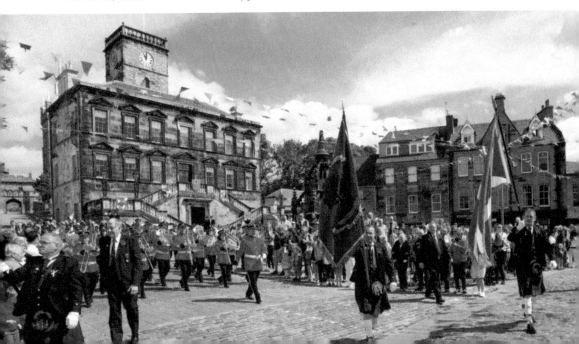

Old Fire Station in the Kirkgate
Although the recent town hall makeover is largely a very successful one, bringing new life and light into the interior, one disappointment is the removal part of its history. For some years, the west gable showed the distinctive signs of a doorway, which once led to the garage and workshop used by the town's fire service. All traces of the door and the surmounted wording 'Fire Engine Station' have gone. The steep slope past the halls leading to St Michael's is the Kirkgate – the street name coming from the Old Norse for 'Church Street'.

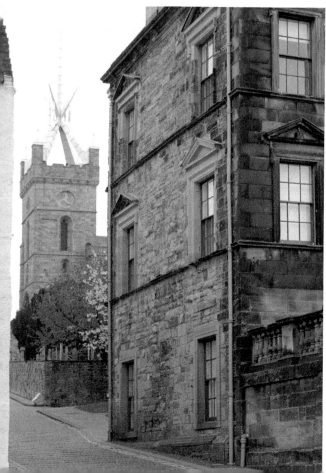

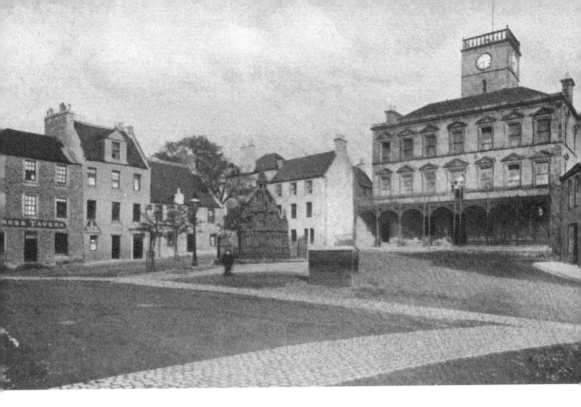

Town Clock and Tron

The town clock was placed in the tower in 1857 and recently restored. In front of the hall was the market place, where stalls were set up around the now vanished mercat cross. The unicorn on the Cross Well is a replica of that which once stood on top. In the foreground of the old postcard above is the tron, the town's weighing machine that was used to determine the fees payable on goods. To the left, is a row of interesting buildings, including the Cunzie Neuk pub, which were demolished in the 1960s.

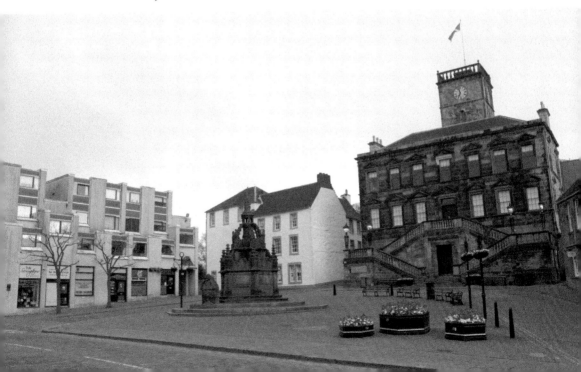

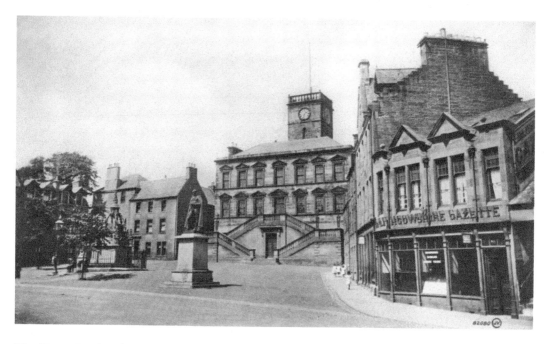

The 'Green Man' and *Linlithgowshire Gazette* Office

In 1911, the site of the tron weighing machine (from the French *troneau*, meaning 'balance') was used to position a statue of John Adrian Louis Hope, 1st Marquess of Linlithgow and formerly Governor General of Australia. In 1970, the statue was removed and placed in the rose garden behind the town hall. The bronze statue has taken on a distinctly greenish hue, earning the Marquess the local soubriquet of 'The Green Man'. To the right of the statue is the building where the *Linlithgowshire Gazette* had its newspaper offices for 116 years until it closed operations in 2013 and moved its headquarters to Grangemouth.

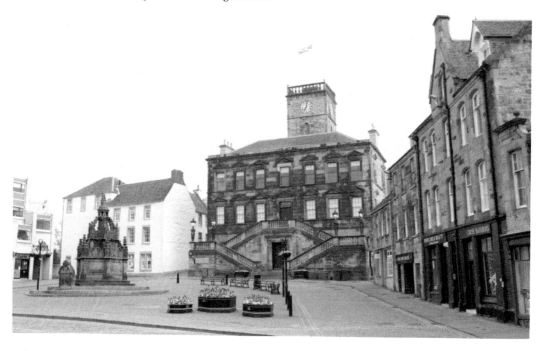

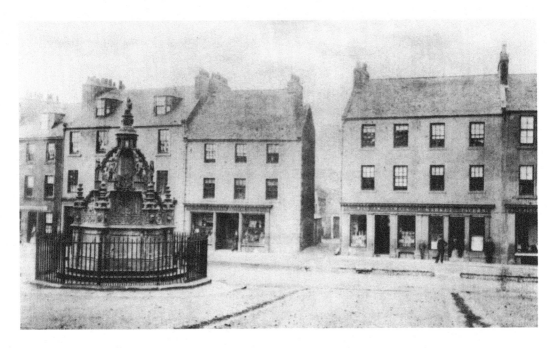

Templar Tenements

To the south of the Cross was a group of eighteenth-century shops and flats known as the Templar Tenements. The commercial outlets were at various times occupied by Henry Duncan the draper's, Manson the baker's, Dymock's market tavern and Simpson's, silk merchants. The buildings gave way to the town's bus depot until 2013 when the garage and associated offices were demolished. The site is being developed into a residential retirement complex to be called Templar Court. On the left of the present view, The Four Mary's pub bears a plaque commemorating Dr David Waldie's efforts in researching chloroform.

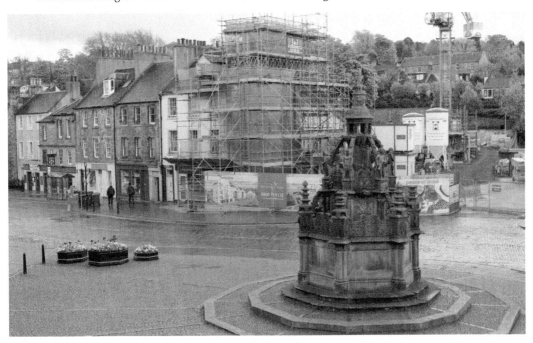

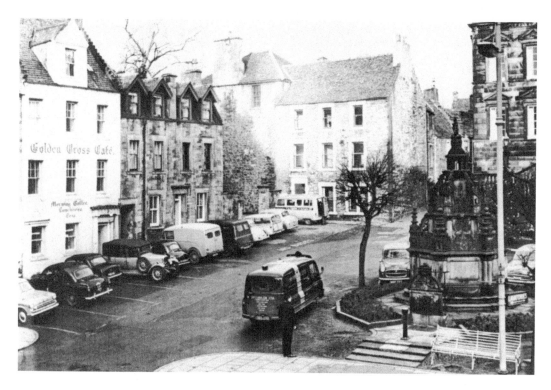

The 'Golden Cross' and Cross House

To the west of the Cross was a group of eighteenth-century buildings, including the Golden Cross Café, in the attic room of which Robert Burns was inaugurated into the local masonic lodge. The demolition of this building was much lamented, especially the destruction of an elaborate, painted wooden ceiling. The replacement edifices, despite winning a Saltire Society award, are regarded by most as not in keeping with the remaining architecture, which includes Cross House – the still existent seventeeth-/eighteenth-century building in the centre of the pictures.

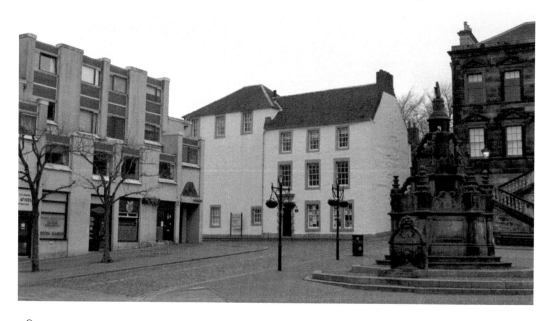

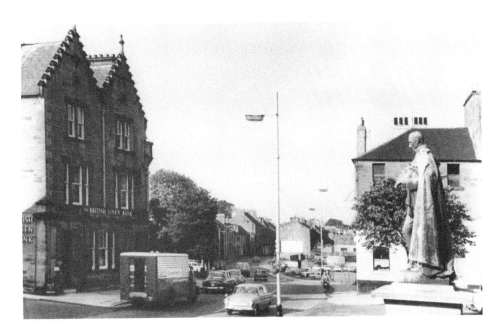

British Linen Bank and the 'Cunzie Neuk'

To the left is the British Linen Bank building, which opened in 1886. Opposite, is the statue of the Marquess of Linlithgow. Behind him, on the corner of The Cross, is the Cunzie Neuk public house. The name probably means 'Cosy Corner' and does not refer to minting coins, as has been suggested. The only coin known to have been minted in the burgh is a silver groat of King James I (1406–37). Behind the Cunzie Neuk, the demolition of the old Vennel area can be seen in progress. Today, the statue has gone and the British Linen Bank (latterly council offices) lies vacant.

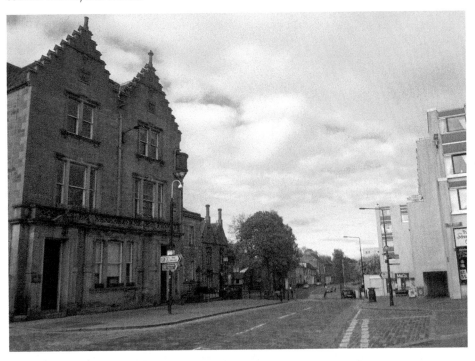

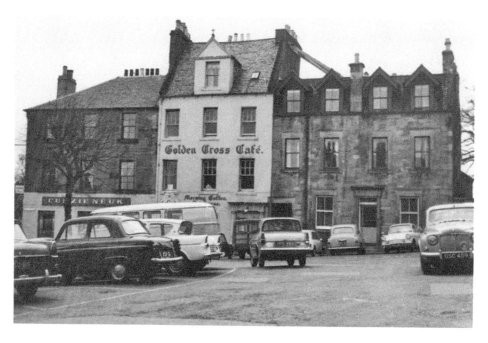

The West Cross

All that is left of the buildings that once stood to the west of The Cross is a carved pediment bearing the coat of arms of Burgh Dean of Guild James Craufurd, and the date 1675. This is now bizarrely installed into the concrete on the right of the replacement building. In front of the Cunzie Neuk is one of the trees gifted to the town in the will of local man John Whitten, who became sheriff clerk of Midlothian and died in 1889. In 1857, the Cunzie Neuk hosted executioner William Calcraft before he performed the last public hanging in West Lothian just outside the pub.

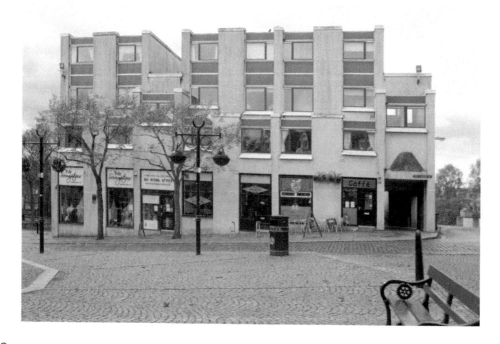

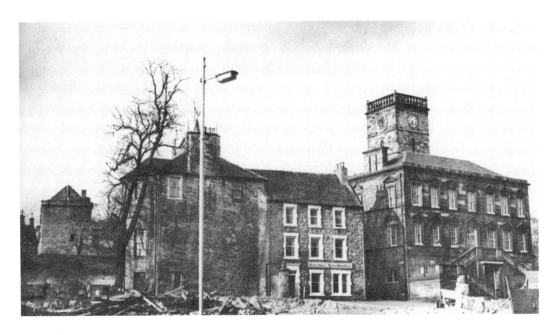

The Cross Brae

The 1960s.brought huge changes to the centre of the town. Initially, the redevelopment plan for the north side of the High Street involved the retention of the historic buildings to the west of The Cross. However, the developers and architects had other ideas and, to complete their vision for the Cross Brae and Vennel area, they decided to demolish the lot. Away went the Golden Cross and the Cunzie Neuk and in their place the 1960s interpretation of good building design, involving flats and commercial outlets, such as Wilson's the newsagents, which moved to this location from No. 220 High Street in 1969.

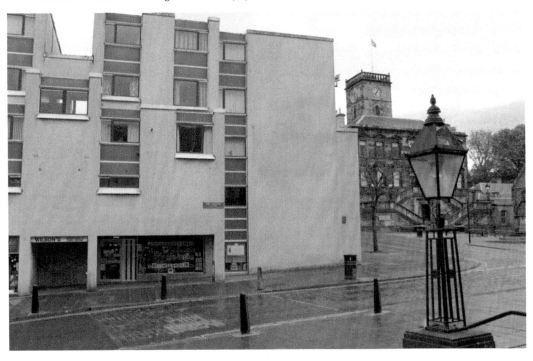

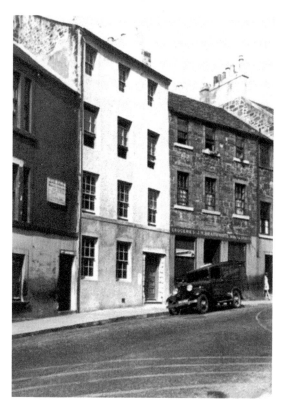

The Spanish Ambassador's House
Another ancient edifice to fall victim
to the developers' demolition machines
was the Spanish ambassador's house.
Although the white-fronted, four-storey
building was never actually the seat
of Iberian diplomats, it stood on the
site of a stately residence that housed
representatives of the Spanish Crown,
including Don Pedro de Ayala, who paid
court to King James IV when he was
resident in the Palace. Unbelievably, the
replacement properties, incorporating
residential flats and commercial outlets,
received a Saltire Housing Award on its
completion in 1969.

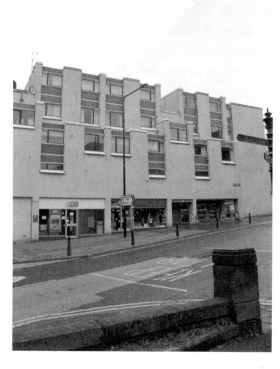

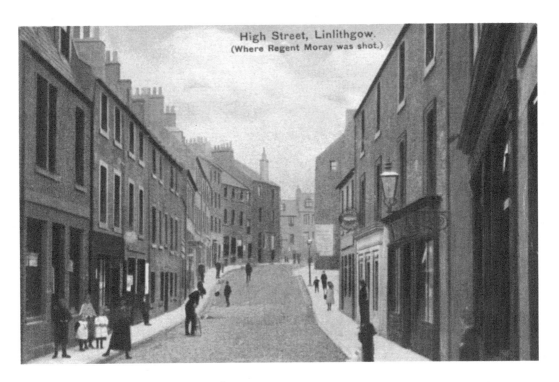

High Street, Linlithgow.
(Where Regent Moray was shot.)

Where the Regent Moray Was Shot

At this point in the High Street, the road once narrowed between the three-storey buildings, making it the ideal spot for an ambush. On 23 January 1570, James Stuart, the Regent Moray, a half-brother of Mary, Queen of Scots, was assassinated as he rode down this slope. The killer, James Hamilton of Bothwellhaugh, had prepared well, blocking up Dog Well Wynd (*bottom right*) with brushwood so that he could not be followed as he made his escape on horseback. The building on the extreme right was once the Dogwell Tavern and is now The Footballers and Cricketers Arms.

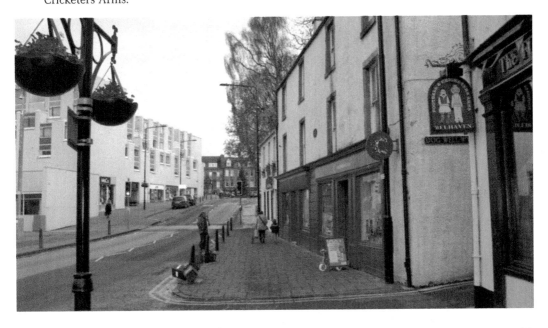

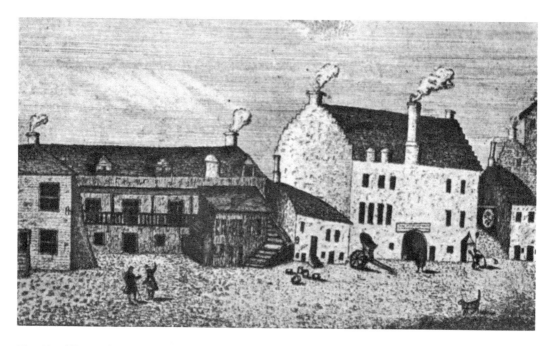

The Sheriff Courthouse

The assassin, James Hamilton, fired to kill the Regent Moray from the building marked with an 'A' on the illustration above drawn by Philip de la Motte. The building, once the property of the Archbishop of St Andrews, was demolished in the 1860s and a new, mock-Tudor building erected in its place. Originally intended as the town's police station, it became the Sheriff Court and was used for county trials until the establishment of a new courthouse in Livingston in 2009. A plaque on the building commemorates the assassination of the Regent Moray. There are plans to convert the edifice into a hotel.

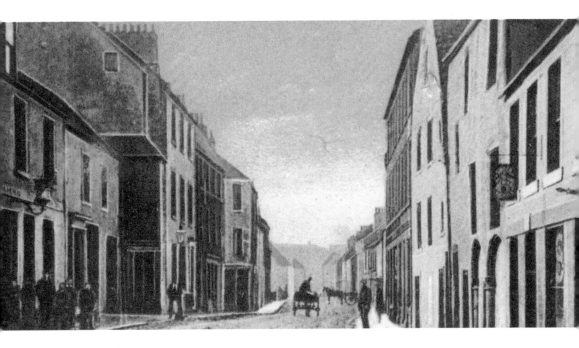

The West High Street

Further west, the High Street became more industrialised, hosting tanneries and shoe-making factories. Spence the chemist's, later Michie's (and now the Fairtrade shop), still has its golden mortar and pestle and beyond that is the town museum, Annet House. Originally built in 1797 as a merchant's abode, it has variously housed a police station, a Civil Defence HQ, the Welcome Home (from the Second World War) committee and a community centre and library. On the right was Lamara's Italian Ice Cream Saloon, now part of the Vennel flats. Opposite is St Peter's (originally St Mildred's) Episcopal church, which was built in 1928.

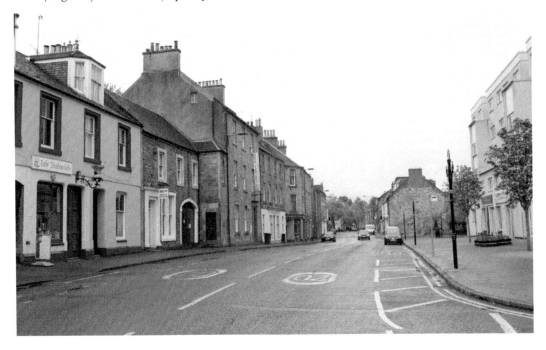

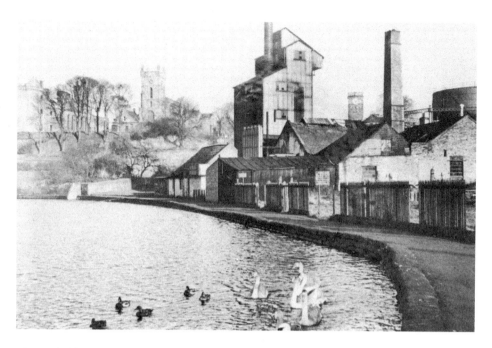

The Lochside and Old Gasworks

Behind the Vennel, on the lochside, was the Linlithgow Gasworks. Originally established in 1830 and later expanded, the industrial plant used the nearby water source for cooling purposes and in turn supplied the fuel to power local industries and the town's gas lighting system. While many lament the passing of the old High Street properties to make way for the concrete, lochside flats, not many mourn the passing of the industrial retort and gasometer. The jetty in the modern view belongs to the Forth Area Federation of Anglers.

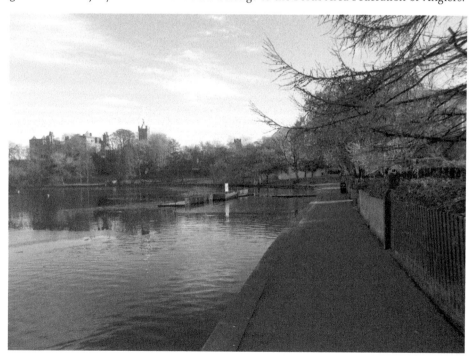

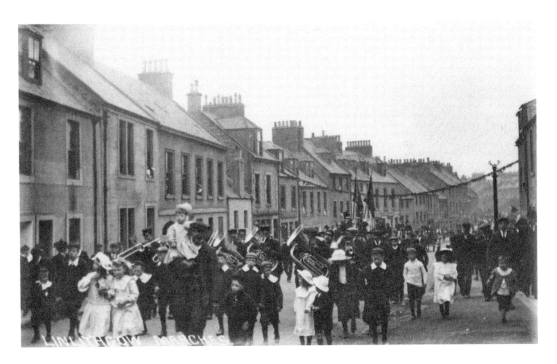

North Side of the West High Street

Also demolished in the interests of modernity and increased housing provision were the properties shown above. These included the Windsor Buffet Public House with its back yard quoiting court and Braithwaite's tailoring business. The 1914 view above depicts a scene from the Riding of the Marches of that year with crowds following the Bo'ness Kinneil Band. At the foot of the slope was a branch of the Bo'ness Cooperative Society – now the health centre. The new, concrete buildings were originally built with flat roofs but pitched roofs were added in 2002.

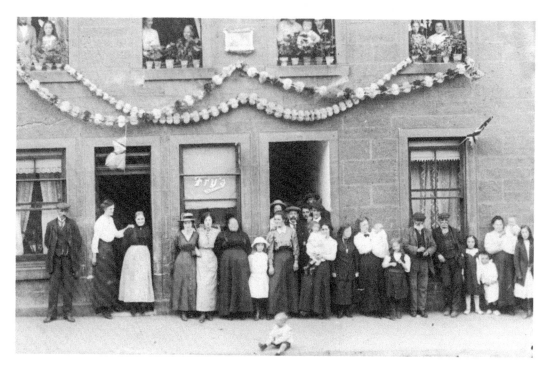

Nos 308–310 High Street

On 11 July 1914, King George V and Queen Mary visited the burgh and here to welcome them, at Nos 308 and 310 High Street, beneath their floral garlands, are the Charlestons, the Harkins, the Sweeneys, the Smiths, the Murphys and the Arthurs. 'Spud' Murphy is on the right, leaning on the windowsill, along with his wife and four of his seven children, all of whom lived in a two-room flat up Macauley's Close, seen in the centre. Today, the close and its associated tenements are gone, replaced by a 1963 development designed by architects Rowand Anderson, Kininmonth and Paul.

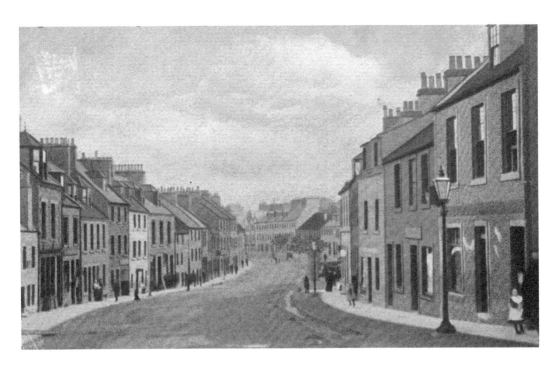

South Side of the West High Street

The scale of what was destroyed by the 1960s development can be appreciated in this 1906 postcard. On the south side of the street, the stone plinth of the New Well is just visible behind the gas light that was lit by the town lamplighter (or 'leerie') going round just before dark. The street is unmetalled and road transport extremely minimal. These days it is very hard to capture the area devoid of cars, which obscure features such as the well that stands today behind a tall, electric light standard, outside a fish and chip shop and close to the redeveloped, late eighteenth-century building called Buncle's Land.

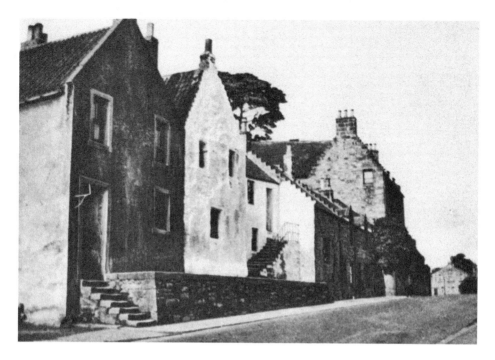

Beinn Castle Brae

Further west, on the south side, was Beinn Castle Brae. It would appear that the name derives from the French *bien* (good) suggesting that, by eighteenth-century standards, the row of quaint dwellings provided comfortable accommodation. The tall, triple-chimneyed building, West Port House, still remains while the two houses to its left have been thoughtfully and successfully combined and restored into an elegant town house by local architect Thom Pollock, who was presented with a European Architectural Heritage Award by the late Queen Mother. The taller buildings were removed in 1930 to create the entrance to St John's Avenue.

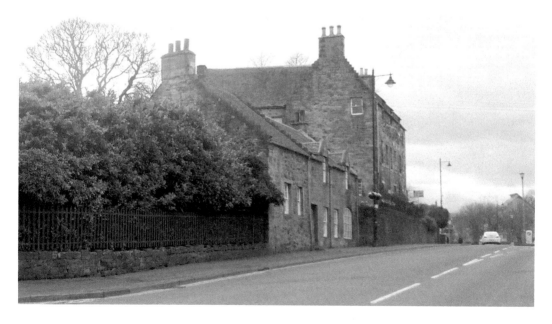

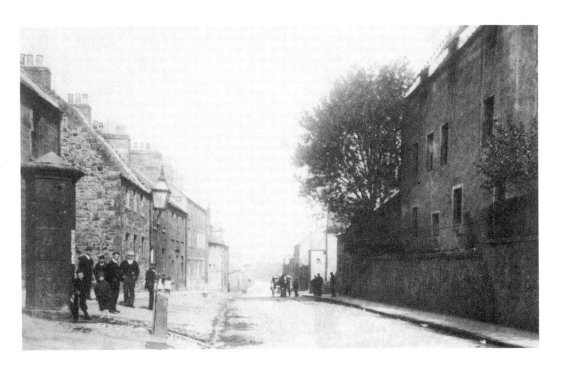

West Port House and Well

West Port House, on the right, was completed in 1600 for the Hamiltons of Silvertonhill and Westport, probably on the site of an earlier building, on land owned by the family since the mid-fifteenth century. It was the family home of the last provost of the Linlithgow Town Council, Dr Bill Wilson. On the other side of the road, is a well tower set up in 1775 to supply water to the local inhabitants. Unfortunately, this 'West Port Well' was hit by a runaway car in the 1950s, removed for repair and never replaced.

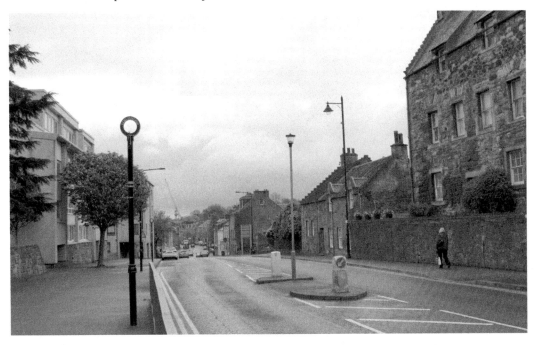

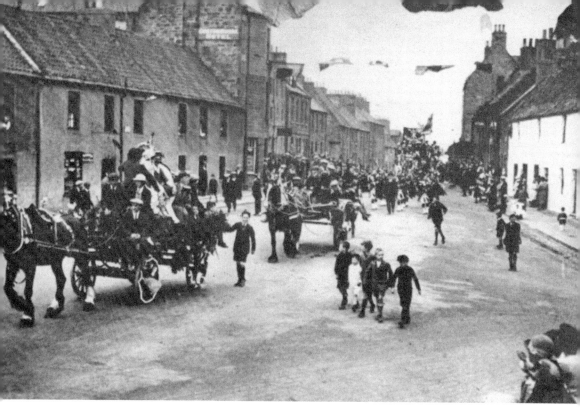

The West Port

The West Port was the entry into Linlithgow through the once existent town wall. The entrance gateway through the defences was removed in the late eighteenth century. The older view shows an early twentieth-century Marches parade entering the West Port area and passing, on the left, the Customs House Hotel. The name comes from the fact that dues were once collected here on all goods entering the burgh. On the right are the West Port Cottages that were removed in 1937 and replaced by council flats designed by William Scott.

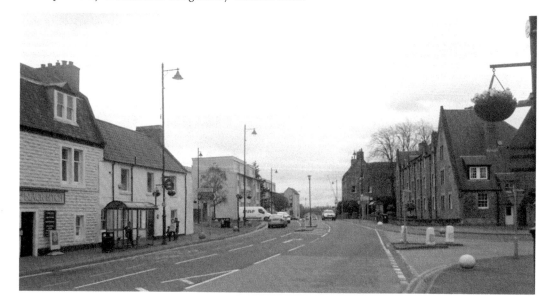

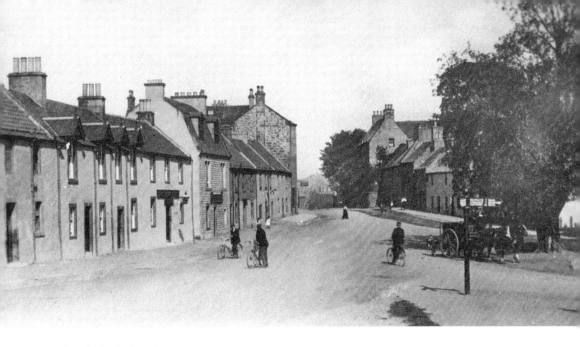

The Black Bitch Pub

For those locked out by the evening closure of the town gateway, inns were constructed where they could spend the night. The customs house has gone but two hostelries remain: The West Port (now a recently refurbished hotel) and The Black Bitch, whose name originates from the town crest, which shows a black, female hunting hound, chained to an oak tree (the symbol of tanning, for which the town was famous). Those born in Linlithgow are proud to call themselves 'Black Bitches'. Beside the ancient weeping willow, is a road leading to Linlithgow's neighbouring towns of Bathgate, Armadale and Whitburn.

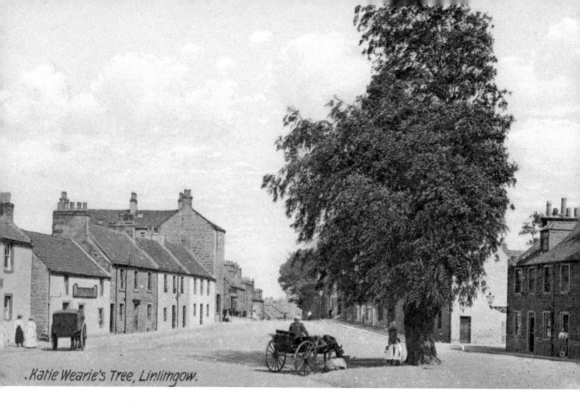

.Katie Wearie's Tree, Linlithgow.

Katie Wearie's Tree
In the older view, a horse drinks in the shadow of Katie Wearie's tree, an ancient willow named after an itinerant cattle drover who sheltered beneath its canopy. The antiquity of the name is shown by the fact that an early nineteenth-century record refers to 'Katie Wearie's Dub', a pond that gathered in the roadway beneath the tree. Later, a horse trough replaced the pond. In 2010, the artist Tim Chalk unveiled a statue depicting his version of Katie Wearie. However, instead of a life-worn cattle drover, it portrays her as a young, attractive, recumbent female resting beside a sundial.

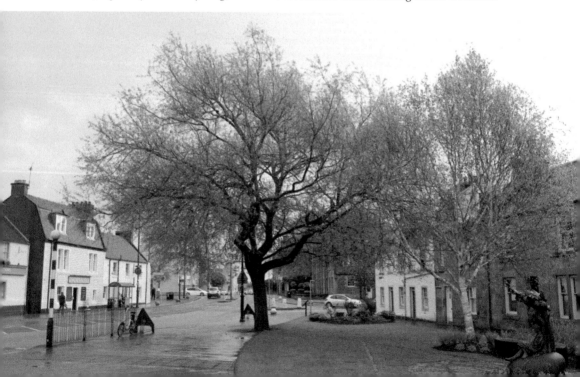

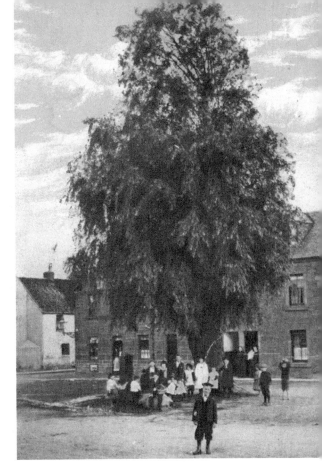

The Collapse and Resurrection of Katie Wearie's Tree

This message on this postcard, posted in November 1911, refers to the 'Great Storm' that had just swept over Scotland. The weather had indeed been awful and had brought down Katie Wearie's tree – ironically the subject of the card. In the view, a group of children cluster round the well that replaced a horse drinking basin. Today, a 'granddaughter' of the original tree still grows on the site. It was planted in 1982 – a sapling of the tree grown from a cutting of the original, which was blown down in 1911. The small cottage on the corner of Preston Road was replaced with council flats in 1937.

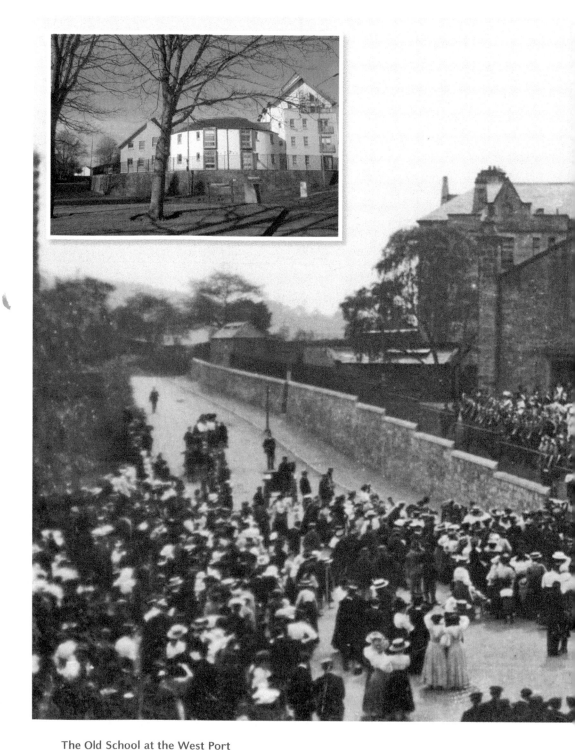

The Old School at the West Port

This large gathering is not a Marches Day celebration; it is Empire Day, 24 May, 1909, and the children of the 'wee school' are gathered in their playground to celebrate the British Empire on what was Queen Victoria's birthday. The school is no more – only the bell gifted

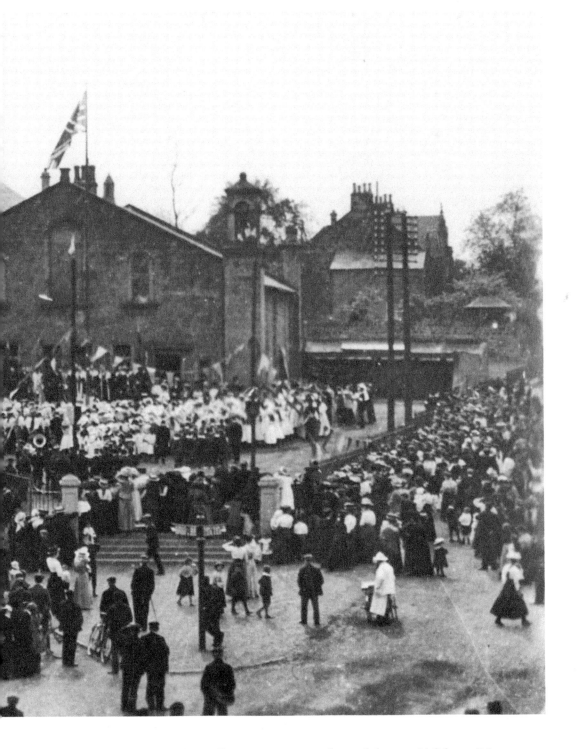

by Mr Reid of Waulkmilton still remains, set up in front of the new Linlithgow Primary School. The building behind was the 1903 public school, latterly an annex of Linlithgow Primary. It was converted into flats in 2004 with a new development constructed in front.

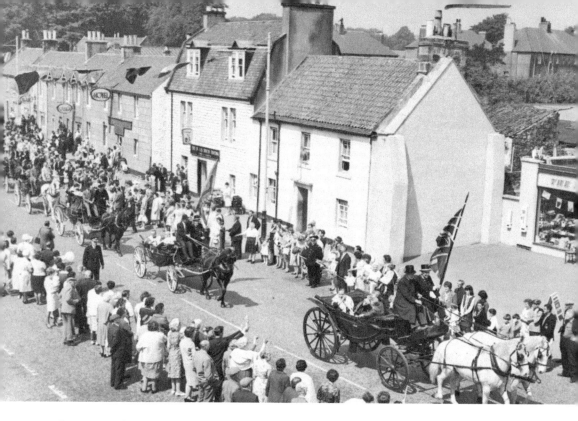

Marches Day at the West Port

In the front carriage, Provost Fergus Byrne leads the 1967 Marches parade. To his left is the Mini Store, now replaced by a Chinese carry-out. Sitting in front of the open-topped landaus, next to the horsemen, are the uniformed figures of the burgh halberdiers (the provost's bodyguards) and the town crier who makes all official proclamations during the Crying (the official notification of the forthcoming celebrations) and on Marches Day itself. Nowadays, it is traditional for the red-robed provost and bailies to dismount at this point and walk, behind the flag-bearers, along the length of the High Street.

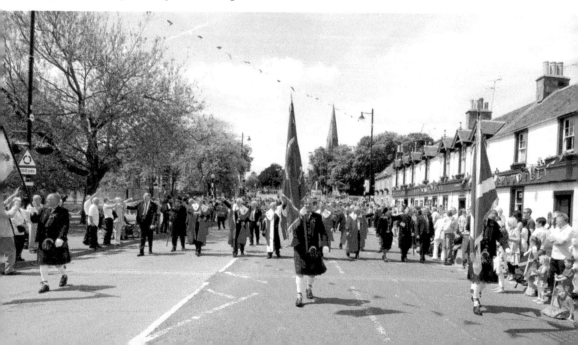

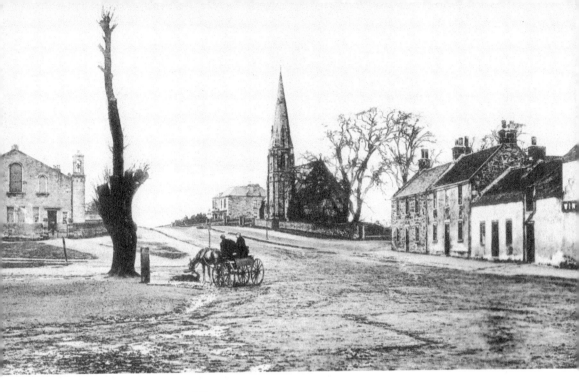

From the West Port to the West

Before its collapse in 1911, Katie Wearie's tree had undergone several indignities, such as the one shown! The spire belongs to a church, built in 1874 as the Free Church, changing its name to St Ninian's in 1929. The first minister of the newly built church was the Revd William Millar Nicholson, while the first incumbent of the united congregation was the Revd Gilbert Elliot Anderson. The church continues as a thriving religious establishment with additional facilities in the Longcroft Hall, which was built in 1869 as an infant school and used later as the first Linlithgow Academy.

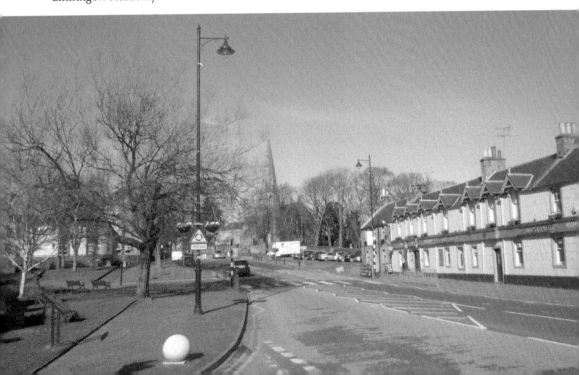

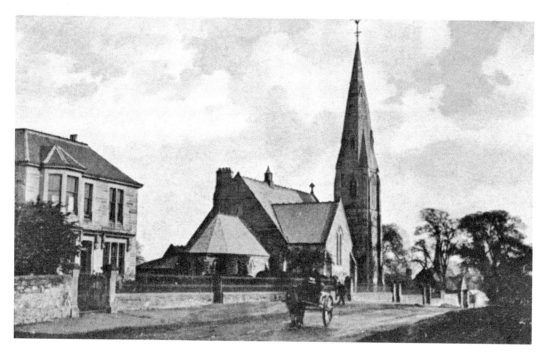

St Ninian's Craigmailen Parish Church

The church began as a Secession congregation, meeting at the 'Preaching Stone' in the Bathgate Hills. Various unifications brought groups together as Free Church organisations and, in 1954, two of these formed the St Ninian's Craigmailen church. The elegant spire was built as part of the original building in 1874. The transept, with its memorial window to Andrew Mickel, was added in 1901. Mr Mickel was a local builder who regularly worshipped in the church until his death in 1888. The house to the left, Southfield, is one of many fine residences that were built for local businessmen in this area.

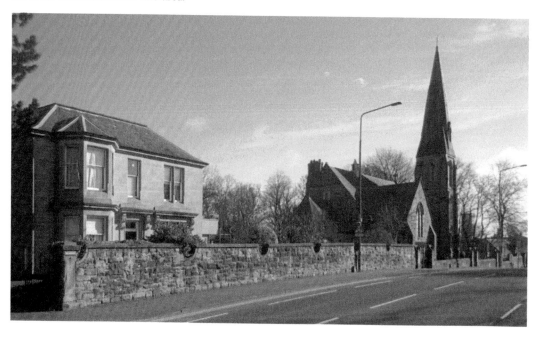

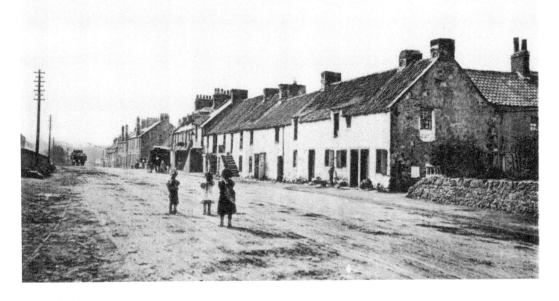

Linlithgow Bridge Housing

Adjoining the burgh of Linlithgow is the village of Linlithgow Bridge. Many of its inhabitants used to work in the mills along the River Avon, which produced grain, printed cloth or paper. Robert Burns visited in 1787 and called in at the Avon Printworks, then under the management of his friend, James Smith. Burns ordered a shawl of a peculiar pattern as a present for his wife, Jean Armour. The modern view lacks something of the charm of the old, unmetalled street but the living facilities and amenities are undoubtedly better. On the right are the 1907 Chalmers Cottages, designed by Sir Robert Lorimer.

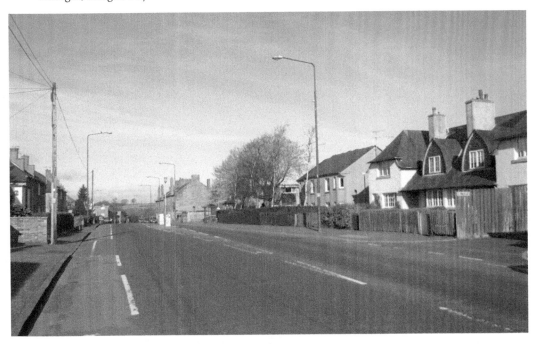

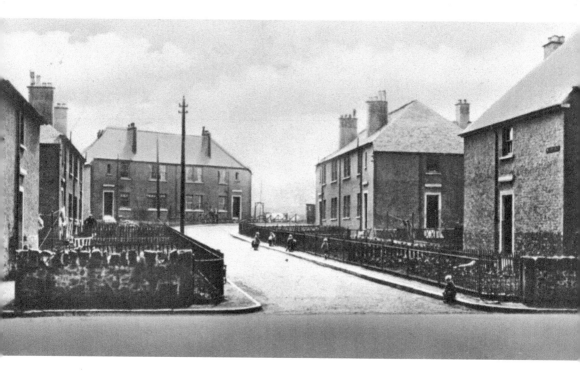

Millerfield

Millerfield takes its name from the large house in the vicinity, which not only owed its title to the mills along the River Avon but to its owners, the Miller family. The buildings in Millerfield Crescent were built as council housing in the early 1930s. The growth of the Linlithgow Bridge community is witnessed by the fact that a separate primary school for the area was opened in August 2002.

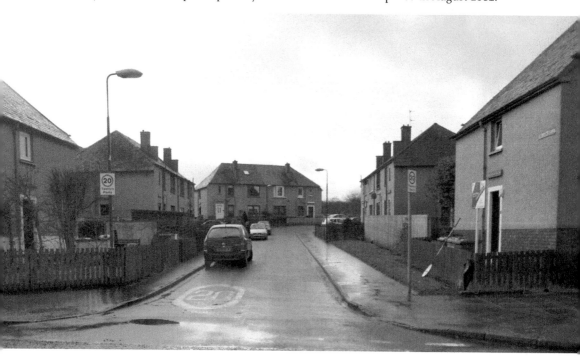

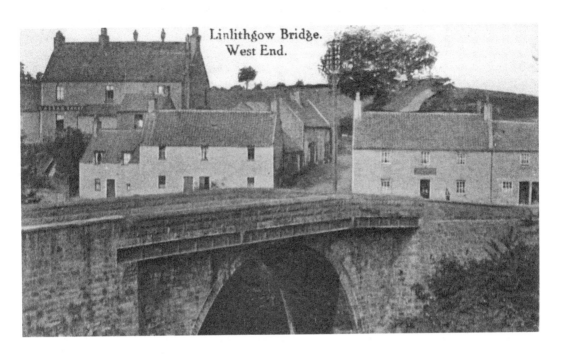

Linlithgow Bridge.
West End.

The Bridge Over the Avon

The original bridge over the Avon was built by the Earl of Linlithgow in the mid-seventeenth century. Ownership was transferred to the Linlithgow Town Council, who obtained the right to collect tolls from all using it. The tollhouse, now long gone, stood on the far side of the bridge. The early nineteenth-century Bridge Inn still stands on the west side of the river – in Falkirk district. This is the westernmost boundary inspected during the Riding of the Marches, now marked by a boundary stone erected in 2013. The nineteenth-century bridge was replaced by a larger, higher structure in 1960.

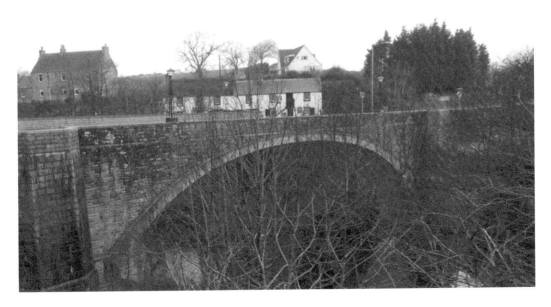

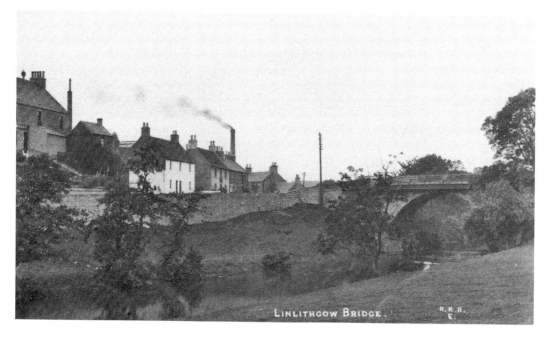

LINLITHGOW BRIDGE.

R.R.R.

Linlithgow Bridge

This view is accessed today through the ground belonging to the fourth West Lothian Scout Troop who use the Mackinnon Hall, the construction of which was made possible through the generosity of Mrs Georgina Mackinnon, whose family operated the Drambuie whisky concern. The white, harled building is the Bridge Inn, which still plays a vital role in the Marches Day proceedings with speeches being made from its external fore-stair. Behind it, in the 1908 view, is the chimney belonging to Avonmill Paper Mill, first set up by the Lovell family in the 1870s. The factory closed in 1971 and is now no more.

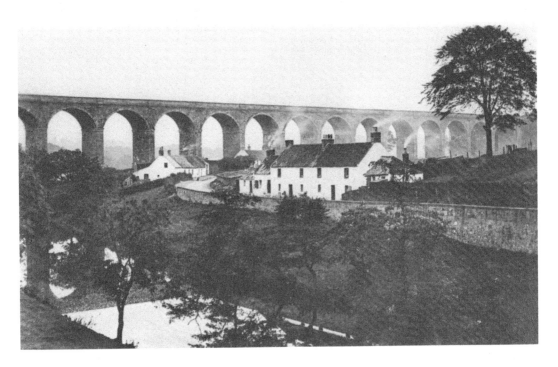

Railway Viaduct

The twenty-six-arched railway viaduct spanning the River Avon was designed by the engineering firm of Grainger & Miller for the Edinburgh–Glasgow Railway, which opened in 1842. It is now a Scheduled Ancient Monument and carries a regular diesel train service from Linlithgow to Edinburgh, Glasgow, Stirling and Dunblane. On the coming of the railway, the council tried to exert its 'ancient right' to charge tolls on rail transport crossing the Avon, but unfortunately lost a long and expensive legal battle when the House of Lords found in favour of the railway company.

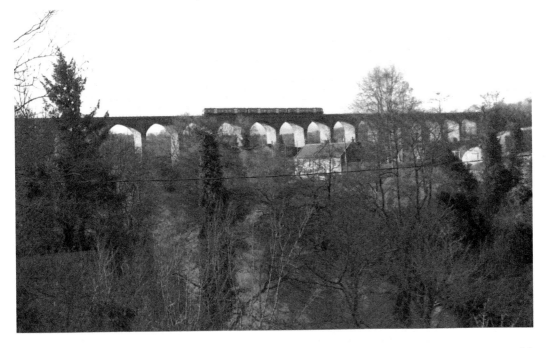

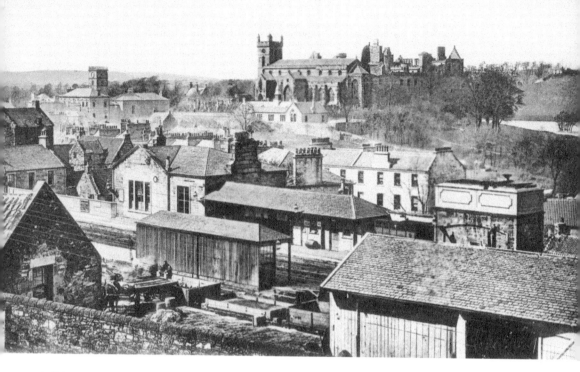

Linlithgow Railway Station

Linlithgow railway station owes its origin to the Edinburgh and Glasgow Railway, which opened in 1842. The original, two-storey, sandstone buildings are still among the best-preserved Victorian stations in Scotland. Recent additions have improved facilities for those using the station, but perhaps to the detriment of the original concept designed by the Grainger & Miller engineering firm. Trees now obscure St Michael's church and the town hall.

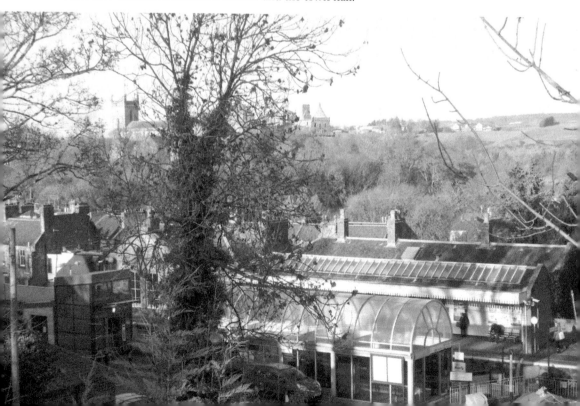

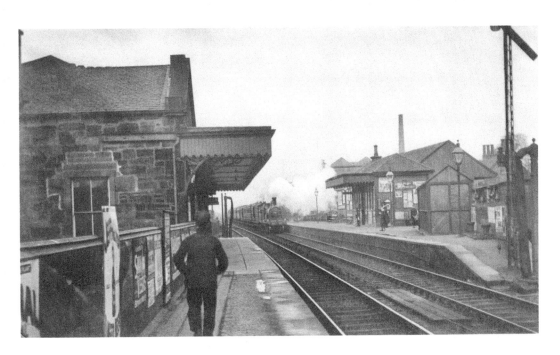

Steam Gives Way to Diesel

Construction on the 46-mile railway line between Edinburgh Haymarket and Glasgow Dundas Street began in 1838. After its opening in February, 1842, four steam trains ran per day each way, taking some 2.5 hours for the journey. Today, there is a much more regular (and quicker) service using diesel units. The most recent major renovation of the station was in 1985 when the then MP for Linlithgow, Tam Dalyell, reopened the new ticket office.

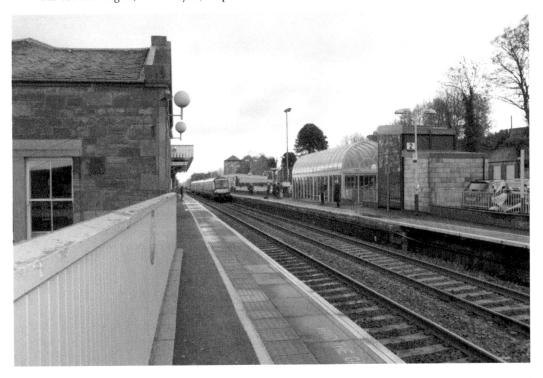

West of the Station

The construction of the railway line led to the destruction of the town wall. The positioning of the station, in the busy heart of the burgh, can pose problems with parking and access. However, the railway has brought many economic benefits and is still a prime reason for commuters moving into the area. The present view is taken from further west as a £1,000 fine is now imposed for straying on the track! The white building is a religious meeting place that bears a notice reading: 'THE WORD OF GOD WILL BE PREACHED HERE ... IF THE LORD WILL.'

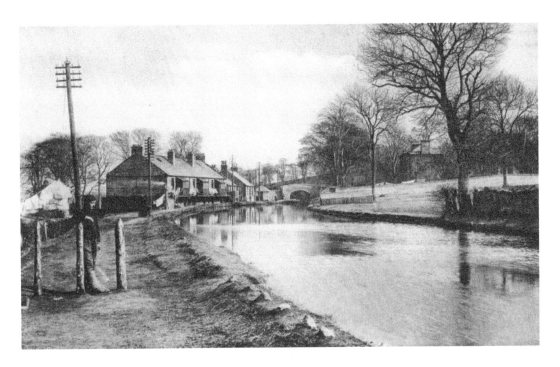

The Union Canal

The coming of the railway was the beginning of the end for the Union Canal. Completed just twenty years before, its role as a cargo-carrying transport link was increasingly made redundant. Its principal purpose had been to provide a cheap means of transporting coal into Edinburgh and Glasgow. It was built as a 'contour canal' – constructed at 240 feet for all of its 31 miles until a flight of eleven locks at Camelon, where the Falkirk Wheel now lifts boats up to the Forth Clyde Canal. The canal workers' cottages on the left have been converted into comfortable homes.

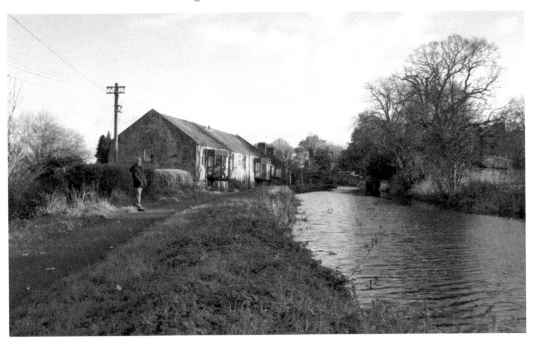

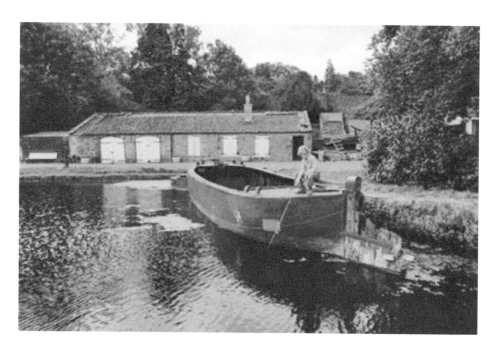

The Canal Basin

Income for the Canal Company was raised through tolls on the horse-drawn barges using the waterway. One of the collection points, where horses were also stabled and passengers could embark and disembark, was the Linlithgow Canal Basin. By the 1970s, the basin buildings had fallen into disrepair and the canal was overgrown and dangerous. The Linlithgow Union Canal Society (LUCS) was formed in 1975 to bring the canal back to life and they have done a wonderful job restoring the basin and renovating the buildings as museum, tearoom and education centre. They also operate regular boat trips.

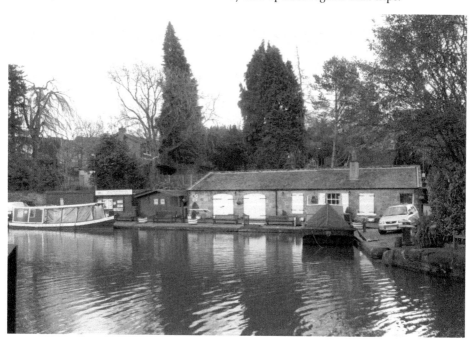

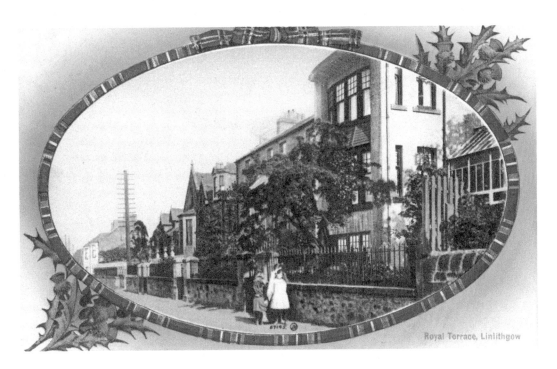

Royal Terrace, Linlithgow

Royal Terrace

The principal founder of LUCS was Melville Gray, who lived in Royal Terrace, a roadway created when the canal and the railway cut through the old High Street rigs and enabled houses to be built to the south of the town. Originally, this part of the street was called Bellevue Terrace and along it are several interesting properties including No. 1, built around 1860, its neighbour, St Margaret's (built slightly later in the garden of No. 1) and the converted Ebenezer Erskine chapel, built in the nineteenth century to house a breakaway branch of the Church of Scotland.

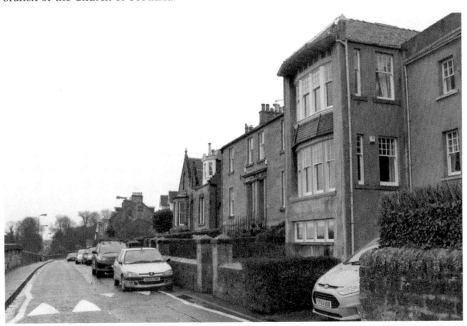

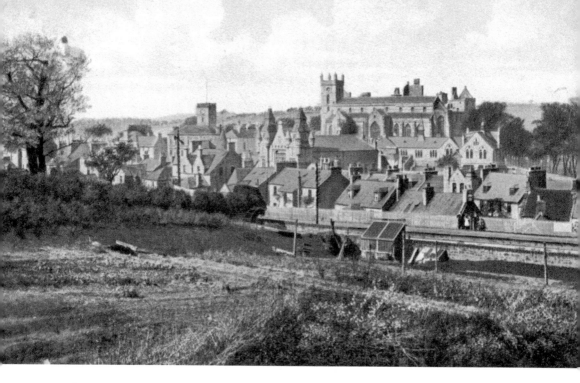

From the Canal Bank

The basic shape of the old town of Linlithgow has changed little. Its long, linear configuration is determined by the fact that building is hemmed in by the waters of the loch and by the canal and railway to the south. The Palace, Parish Kirk and Burgh Halls stand where they have done for centuries. The other towers seen in the top picture, and removed in the lower, belong to the Victoria Jubilee Hall. Also visible, in front of the church, is the long, low building of Linlithgow Grammar School – destroyed by fire in 1902.

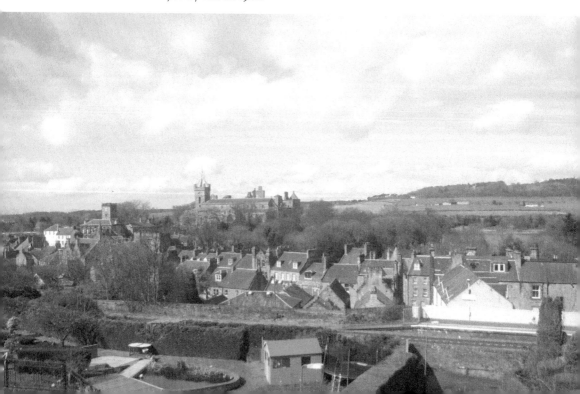

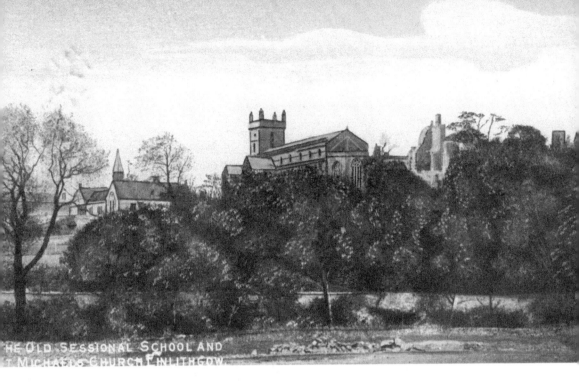

THE OLD SESSIONAL SCHOOL AND
ST MICHAEL'S CHURCH LINLITHGOW.

Linlithgow Grammar School

The Grammar School (or Secession School) to the left of St Michael's church owed its original foundation to a charter of Pope Gregory VIII in 1187. The original school, probably a 'sang schule' training choristers for the Roman Catholic services within the nearby church, was demolished by Cromwellian troops. A replacement was built in the 1670s and, with various extensions, continued in operation until February 1902, when a fire largely destroyed the fabric. The area became a curling pond and then a rose garden. Today, it needs a creative overhaul.

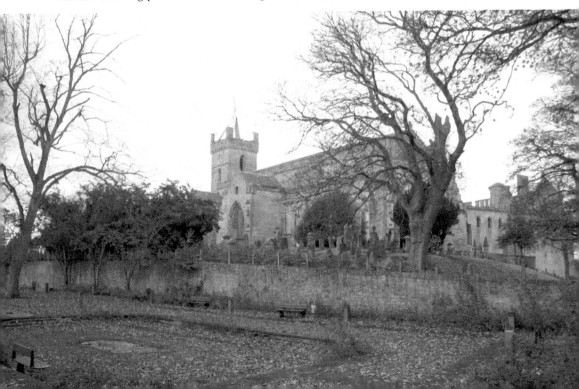

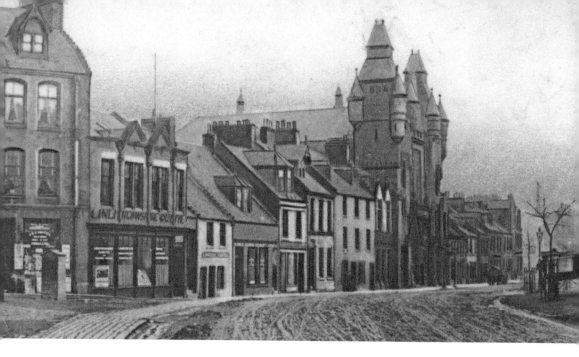

The Victoria Jubilee Hall

When the grammar school burned down, the pupils were taught in various premises throughout the town, including the Victoria Jubilee Hall, built to celebrate sixty years of the Queen's reign. With its distinctive towers and baronial turrets the hall was welcomed as a venue for public gatherings, shows, concerts and church soirées. The foundation stone was laid with masonic splendour by former Prime Minister the 5th Earl of Roseberry on 31 December 1887. Today, shorn of its Gothic embellishments and imposing, stained glass window, it is an embarrassing shadow of its former self and awaiting redevelopment.

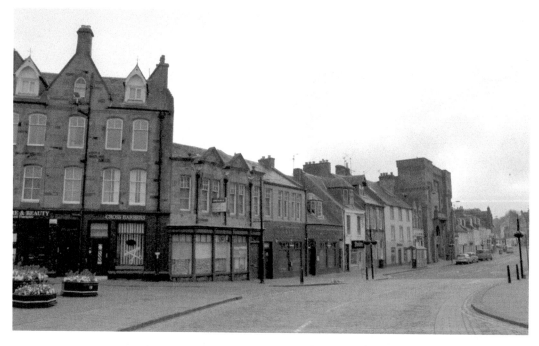

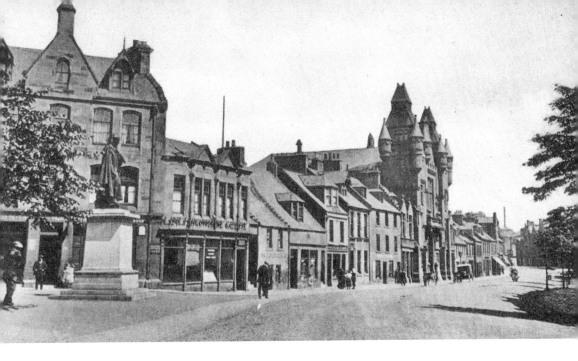

The Green Man

Another local peer of the realm associated with this area was John Adrian Louis Hope, 1st Marquess of Linlithgow. A statue of him, in his robes of office as Queen Victoria's Governor of Australia, was erected at The Cross on 5 October 1911. Sadly, the statue got in the way of traffic management at this busy spot. Now, with a distinct greenish hue, he is relegated to a site behind the Burgh Halls, in the shadow of St Michael's graveyard.

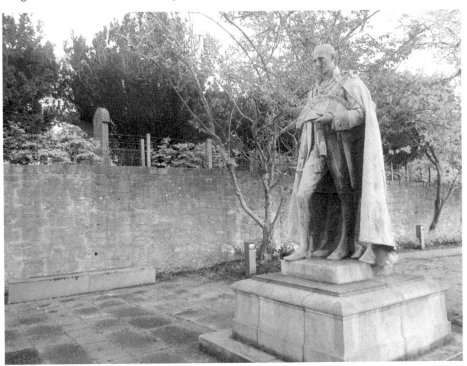

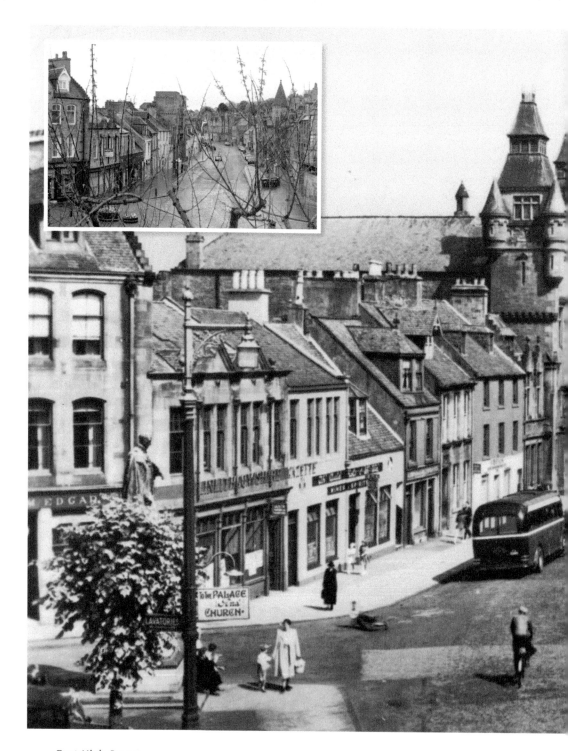

East High Street

The earlier view of the High Street was taken from a top window of the Cunzie Neuk public house, which was demolished in the 1960s. It shows a Scottish Motor Traction bus belonging to the company, which started trading in 1905. The SMT bus is parked at the still

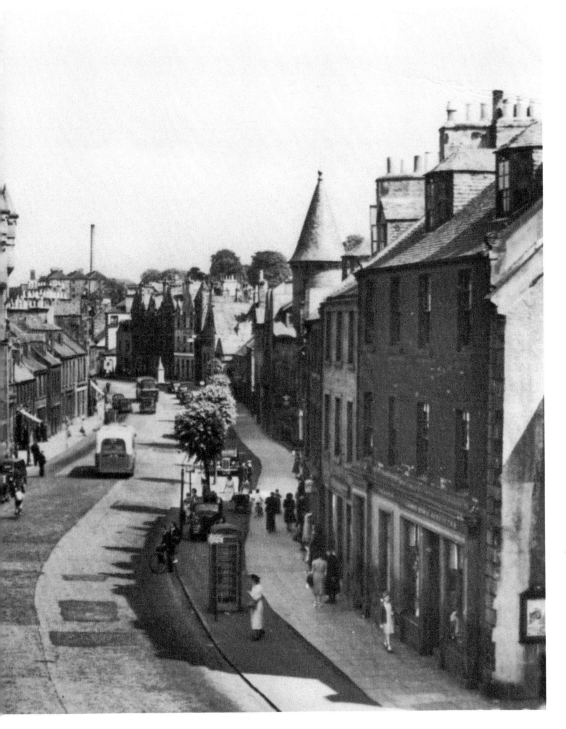

operating stop outside the Auld Hole I' the Wa' pub. The same view today can be had from an upstairs room in the Vennel Flats. On the right, a bus shelter stands outside The Four Marys, which was once the home of David Waldie, who is widely credited with being the first man to produce the anaesthetic chloroform.

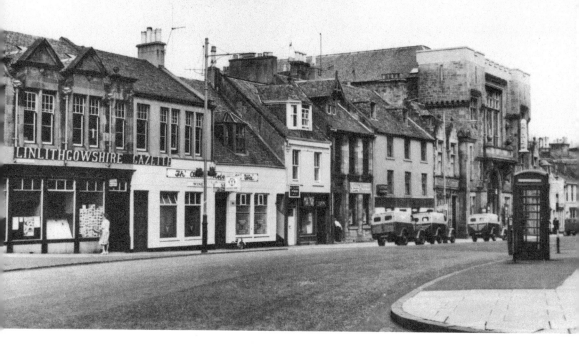

The Ritz Cinema

The Auld Hole I' the Wa' pub is an ancient hostelry where, initially, drink would be served to the public through an aperture in the wall. To the right is the Victoria Hall, which became the 1,000-seat Empire Cinema in 1937. Later, it was sold to Caledonian Associated Cinemas, whose architect, Alexander Cattanach, converted it into the Ritz Cinema, drastically altering the roofline. From 1972, the building became a bingo hall, and then an amusement arcade, locally called The Puggies. In 2008, the rear of the building was demolished leaving only the dilapidated High Street frontage.

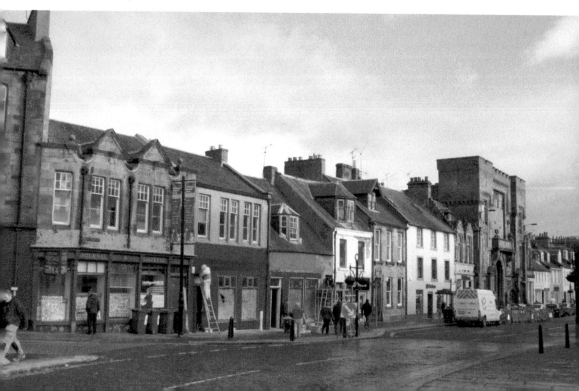

The New Spire of St Michael's
In 1964, there was great excitement in the town with the erection of a new spire on St Michael's church – seen here emerging above and behind Greig's furniture shop and Macnab's dry cleaner's. The topmost, 58-foot finial, made of timber clad in anodised aluminium, was lowered into place from a helicopter. The designer of the modern (and, at the time, controversial) construction was eminent sculptor Geoffrey Clarke, who had made a name for himself by designing artistic creations for Coventry Cathedral. Today, it is largely regarded as an icon of the burgh, visible for miles around.

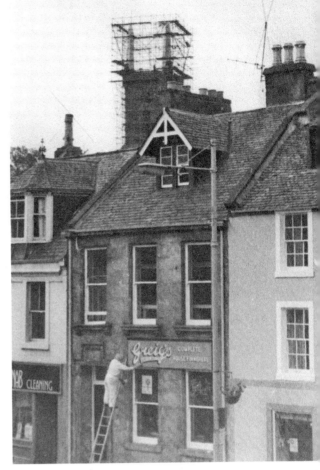

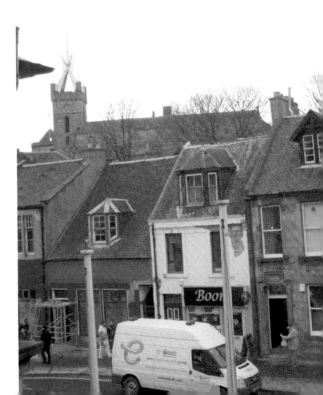

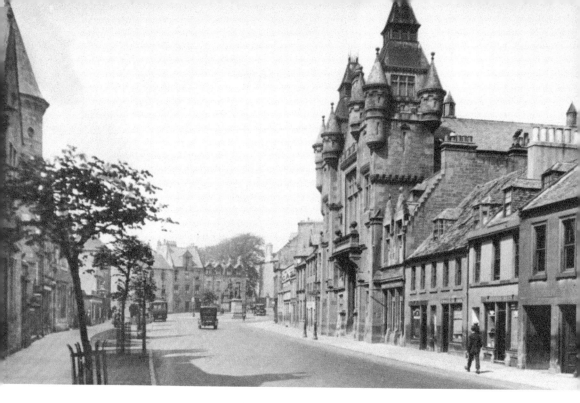

Looking Back to The Cross

The early picture shows the Victoria Jubilee Hall in all its mock Gothic splendour. Built to show 'loyal regard for Her Majesty' in the Jubilee year of her reign, it was constructed on the site of a seventeenth-century tenement called Brockley's Land. To its right is a still existent line of interesting buildings, their rooflines set at different pitches, perhaps reflecting the weather conditions during the time of their construction. On the right, is the tower of the Commercial Bank of Scotland and the low roof frontage of The Four Marys – earlier used as a chemist's shop and printworks.

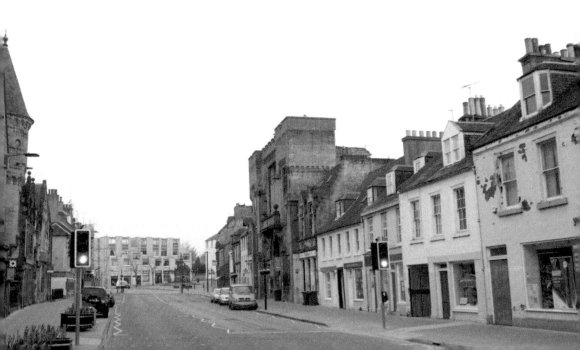

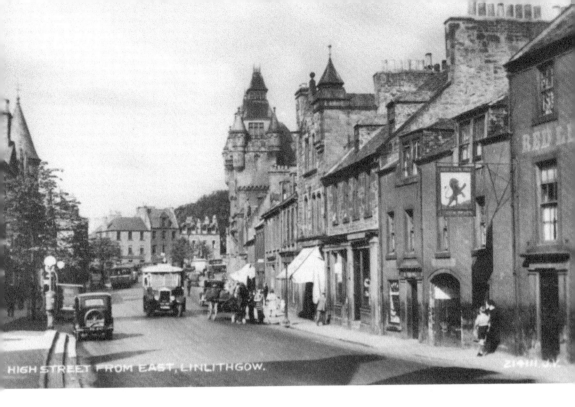

HIGH STREET FROM EAST, LINLITHGOW. Z14111 J.V.

The Red Lion

Behind the bus, in the 1920s view, are the properties at The Cross that were demolished in the 1960s. Along from the horse-drawn coal cart, is the Red Lion Hotel – now the Bar Leo Italian restaurant. On the night of 1 February 1857, a contingent of Dragoons was quartered there. Their task was to ensure that no disorder occurred at the public hanging of Peter Maclean at The Cross – the last such punishment in the burgh. Opposite, is the petrol pump of Donaldson's Garage, selling Ross's petrol, which was refined from oil produced from the shale fields around the town.

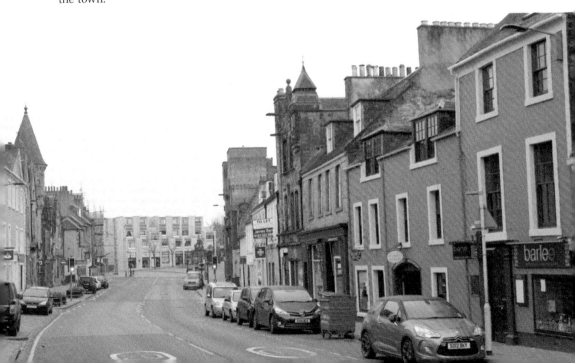

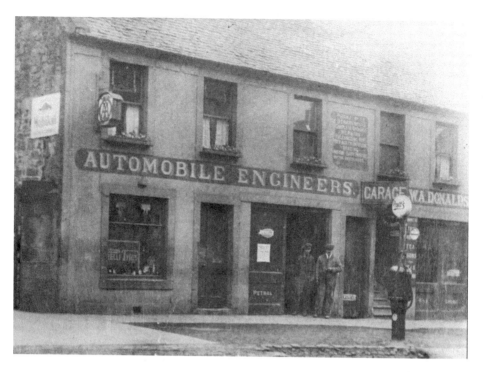

Donaldson's Garage

In the older view, the hand-operated petrol pump of Donaldson's Garage is being used to dispense Pratt's petrol – perhaps not surprisingly later rebranded as Esso. Donaldson's proud boast was that he possessed the oldest petrol pump in Scotland, a claim somewhat in doubt when the Newton Garage, 6 miles to the east, boasted that it had the oldest pump in West Lothian! The building for many years hosted the Signet Tie Co. and is now a bookmaker's.

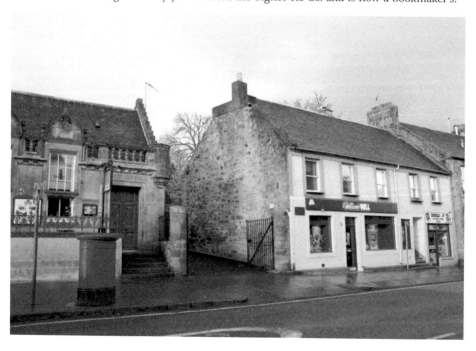

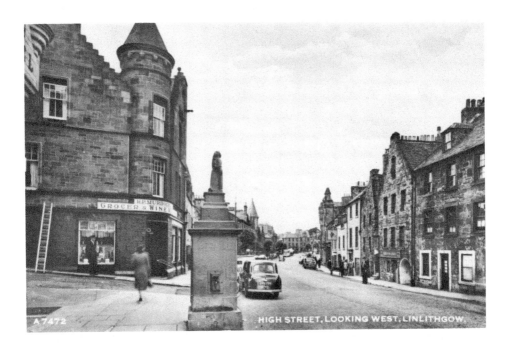

HIGH STREET, LOOKING WEST, LINLITHGOW.

St Michael's Well

R. P. Murdoch's grocer shop was succeeded by Harrison the Ironmonger. Today, it is home to Purely Patchwork quilt shop. Beside it is a well dedicated to St Michael, the patron saint of the burgh. The figure of the archangel stands atop a stone plinth dated 1720 with the inscription 'ST MICHAEL IS KINDE TO STRAINGERS' – a phrase adopted as the town's motto. The carved figure of the saint may be from an even earlier well.

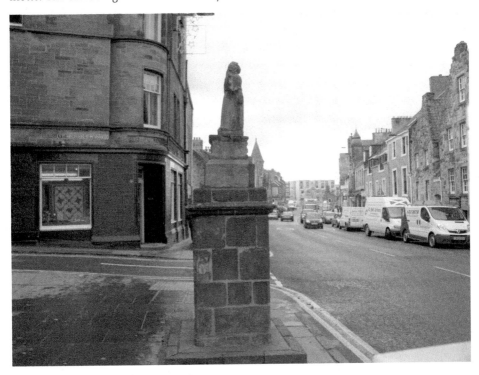

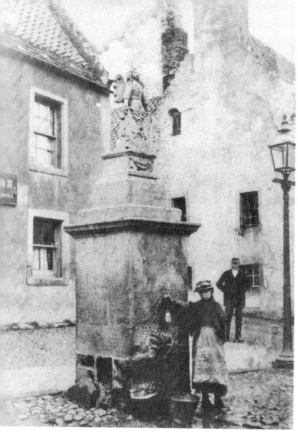

St Michael's Well in Use

The older view shows St Michael's well in use around 1890. To the left is a building associated with 'The Mint', the early sixteenth-century residence of the Knights of St John. The High Street frontage backed onto a courtyard dominated by a tall, black tower and a magnificent hall with a timbered, hammerbeam roof and a large, decorated fireplace. The buildings were demolished in 1885 in order to build St Michael's Hotel. In turn, this was converted into flats in 1992.

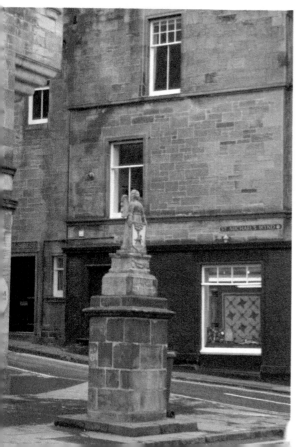

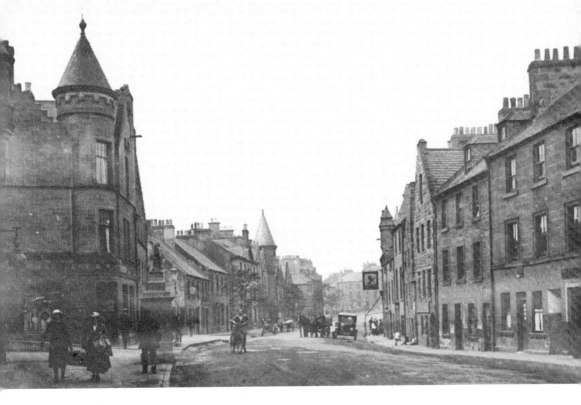

The High Street Towers

The 1931 view of the East High Street also features St Michael's Well. Above it are two pointed towers: the first, in the foreground, being on the corner of St Michael's Wynd, and the other built for the Commercial Bank of Scotland in 1859. The letters 'CBS' are still above the doorway, although it is now the Royal Bank of Scotland. To the right of The Red Lion pub sign is Hamilton's Land – now given over to small shops but built in the early seventeenth century as the town house of the Hamiltons of Pardovan. The unsightly construction in front of the well is an air quality monitor (which, hopefully, is temporary).

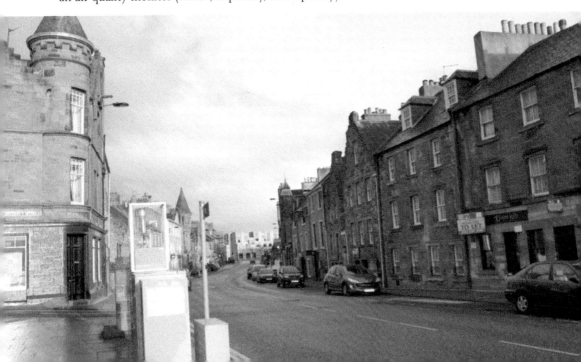

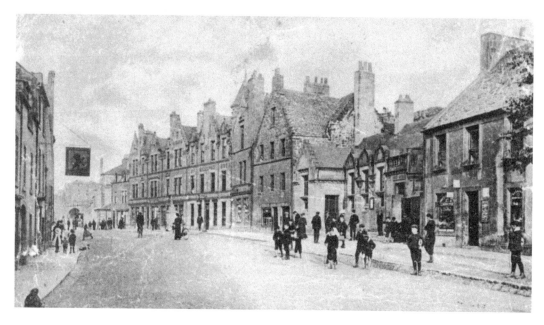

The Old Post Office

Looking to the east in the early view, past the Red Lion pub sign, is St Michael's Hotel, with its intricate skyline of dormer windows. To its right is an interesting eighteenth-century building, which still houses a bakery as it has done for over 100 years. Next to that, the low, Scots Renaissance building was opened in 1903 as the Linlithgow post office, replacing a previous outlet at The Cross. It has been converted, along with the backyard sorting office, into a pub/restaurant under the name The Old Post Office.

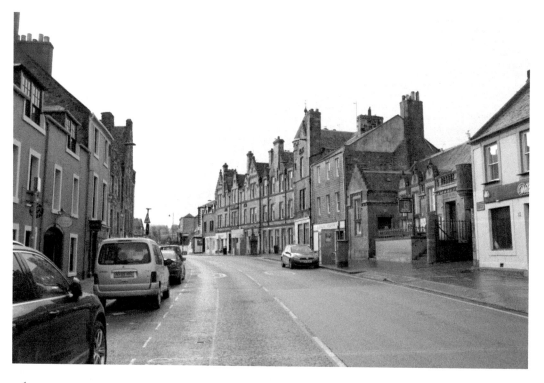

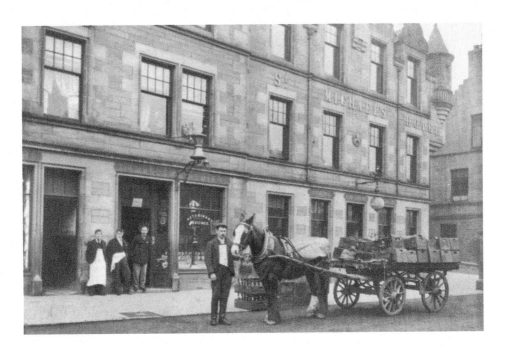

St Michael's Hotel

In the 1890 photograph, a carter is delivering supplies to Lumsden's chemist's next door to St Michael's Hotel. Lumsden's Lemonade factory was situated on the old Edinburgh Road. The Lumsden family looks out of their window to the side of the mortar and pestle sign. To the right of the unusual light fitting, in St Michael's Wynd, is a stone inscription declaring 'Hame's Best', an abbreviation of the old saying 'East, West – Hame is Best'. St Michael's Hotel was opened in 1886 to serve travellers arriving in the town from the nearby railway station. The hotel was converted into flats in 1992.

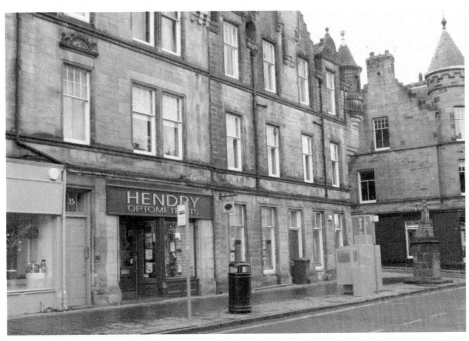

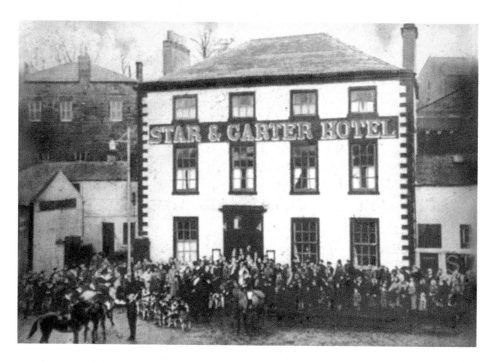

The Star & Garter

This building was built for Provost John Boyd in 1759, the year of Robert Burns' birth. Eighty-eight years later, it became a coaching inn and remained so under the proprietorship of nineteenth-century publicans such as James Burleigh, John Whitten, John Maddox and Thomas Woodcock. In the twentieth century, its owners included Mrs V. McMinn, 'Miffy' Boyd, Ronnie Pearce, David Bryce, Hugh Keenan, and Bill Atkinson. It was a regular meeting point for the Linlithgow and Stirlingshire Hunt (founded in 1797), which used the stables to the left of the hotel. It has recently been restored and renovated.

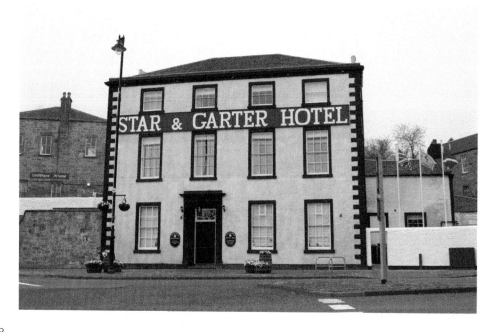

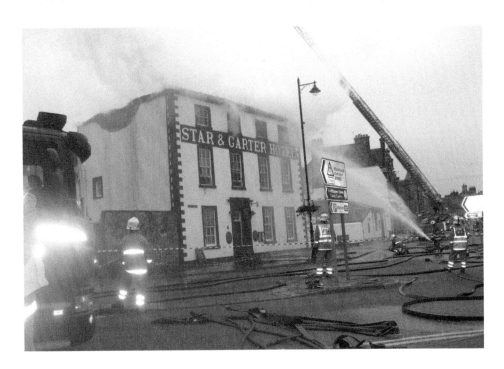

The Star & Garter Fire

On 15 October 2010, the Star & Garter Hotel was largely destroyed by fire. Sixty firemen just succeeded in stopping its complete collapse. Hundreds of locals turned out to witness the gutting of a structure that had played host to countless meetings, weddings and society functions. Many organisations had convened in the building, including the Linlithgow Bowling Club, which was constituted there in 1881. A local trust set about raising funds to restore the building but instead two local businessmen, David Kennedy and Ross Wilkie, stepped in and employed local architect Thom Pollock to handle the restoration, which was completed in January 2014.

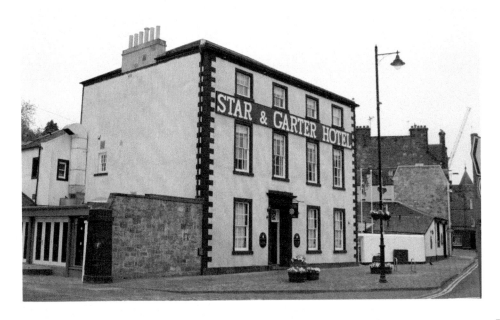

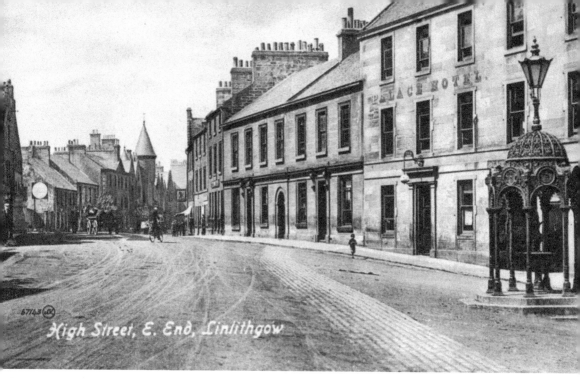

High Street, E. End, Linlithgow

The Whitten Fountain

Outside the Star & Garter, there once stood a wrought-iron construction called the Whitten Fountain. It was commissioned in 1890 using a legacy of Sheriff John Whitten, a relative of the hotel owner, also called John Whitten. The ancient town gateway that stood at this point has now gone but is marked by brass studs in the roadway. The 'Palace Hotel' lettering can still be seen on the frontage of Nos 16–18 High Street even though the place stopped trading many years ago. This hotel operated its own carriage and horses to collect passengers and to conduct tours of the area.

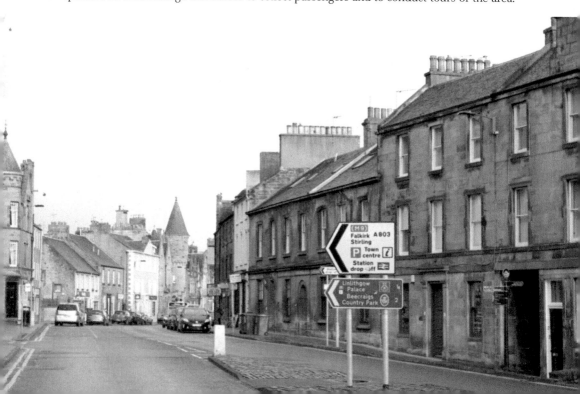

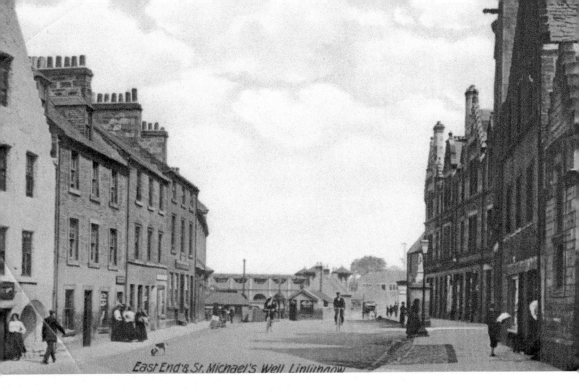

East End & St. Michael's Well, Linlithgow

The Nobel Explosives Company

The east end of the High Street once culminated in the imposing, Italianate façade of the Regent Works, built to house the Nobel Explosives Co., which was set up in 1902 to produce fuses and other materials for mining in West Lothian and abroad. The factory was named after the Regent Moray, who was shot in Linlithgow High Street in 1570. Were they trying to make a connection between that and the use of explosive powder?

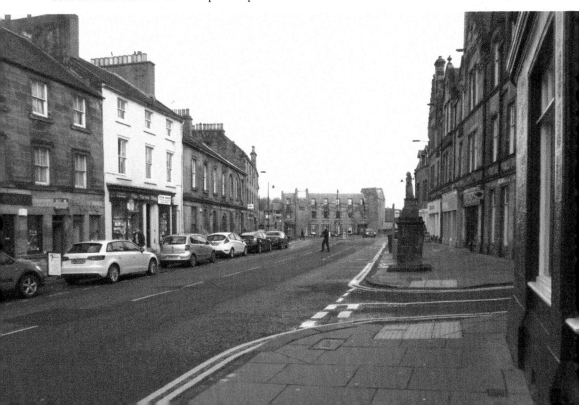

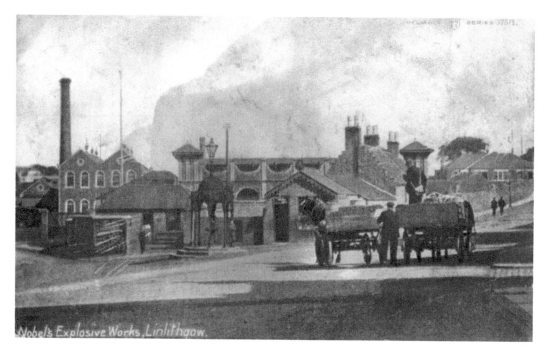

Nobel's Explosive Works, Linlithgow.

Working for Nobel

The wrought-iron Whitten Fountain in the middle of the roadway was removed as scrap metal during the Second World War. Behind it, the Nobel Explosives Co. used to produce 200 miles of fuse wire each week – most of it exported to Australia to supply the growing mining industries there. Each employee worked a fifty-seven-hour week and, in addition, was given 1,027-foot lengths of wire to take home each evening and, with the assistance of his family, coil into the required size. All traces of the factory have now gone.

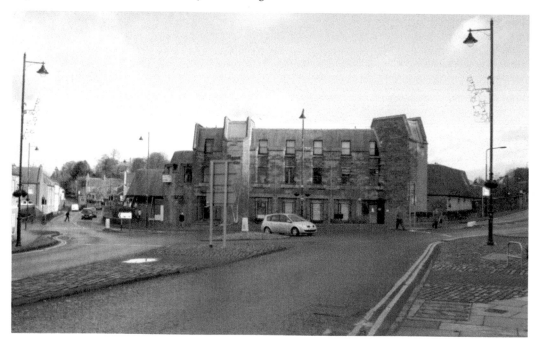

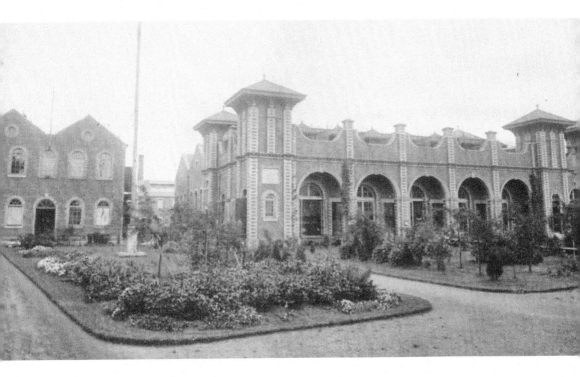

The Regent Works Façade

The elaborate, arcaded brick frontage of the Regent Works, with its Italianate towers, was added some six years after the orginal plant opened. It was designed by Linlithgow architect William Malcolm Scott. The two world wars saw the Regent Works on armament production with most of the work being done by women. Several of these local 'munitionettes' became ill through contamination with TNT or sulphur. The yellow hue of their skin earned them the nickname 'canaries'. The well-kept gardens have gone although the existing flower beds are nicely managed by Burgh Beautiful.

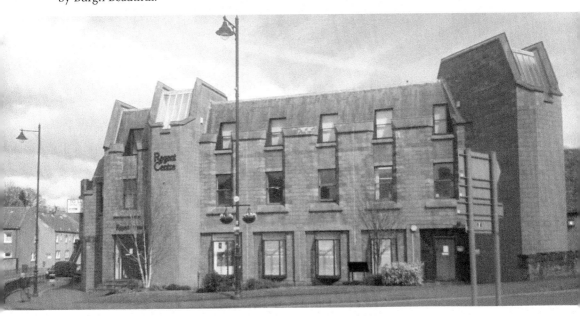

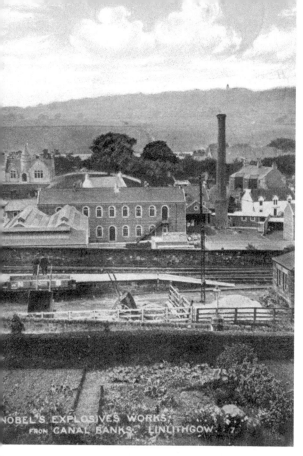

NOBEL'S EXPLOSIVES WORKS
FROM CANAL BANKS. LINLITHGOW. 7

The Nobel Factory from the South
A shopping complex now takes the
place of the Nobel Works where,
by 1939, over 500 employees were
turning out thousands of incendiary
and signal bombs, smoke floats and
photographic flashes. As a committed
pacifist, Alfred Nobel was concerned
at the possible misuse of his invention
and consequently left his fortune in
trust to pay for future Nobel prizes.
The dangerous nature of work in the
Linlithgow factory was brought home in
February 1943, when an explosion led to
the death of three women and serious
injuries to others.

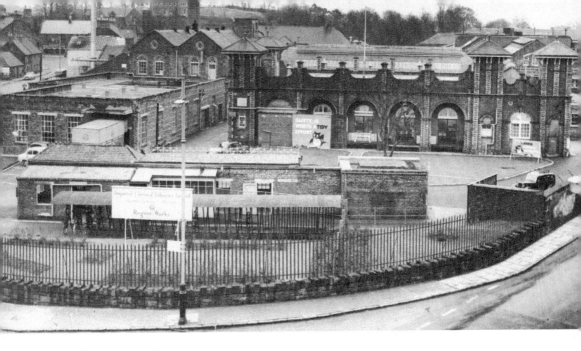

ICI Take Over Nobel's

By the time production in Linlithgow ceased in July 1945, almost 11 million incendiary bombs had been produced. By then, Nobel's Explosives Co. had been absorbed into Imperial Chemical Industries (ICI) and, by 1972, this division was an independent trading organisation. In this guise, it produced, among other products, Savlon antiseptic cream. Production ceased soon after and the 3.5-acre site became home to a variety of small enterprises before being demolished in 1982 to make way for the Robert Hurd designed complex, which now houses the Tesco supermarket.

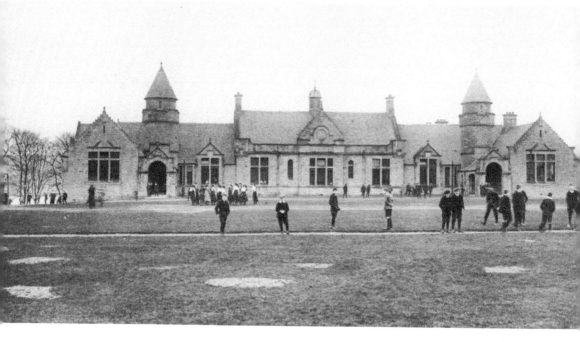

The Second Linlithgow Academy

Over the Low Port roadway from the explosives factory was a school, opened on 12 May 1902 as Linlithgow Academy (the original being Longcroft Hall at the West Port). The site was formerly a sand quarry and a showground for visiting fun fairs. The West Calder-born architect James Graham Fairley designed the building in Scottish Baronial style with towers reminiscent of those on Holyrood Palace. Fees were originally charged although some able children were admitted free of charge. Today, the building houses the Low Port Primary School.

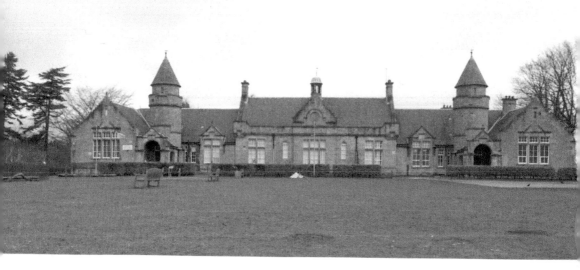

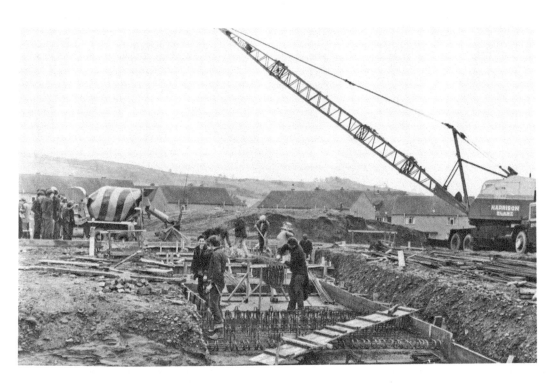

The Third Linlithgow Academy

A 1963 school magazine article stated, 'The new Linlithgow Academy will be constructed on a site dominated by a slaughter house, a cemetery, the Braehead Housing estate and a railway line.' As shown in the older photograph, the firm James Harrison & Co. began work in 1966 and Margaret Kidd, a former pupil and the first woman to be a King's Counsel, opened the building in December 1968. The school began with a roll of 460, including Alex Salmond, later to become First Minister of Scotland. Today, the roll is over 1,200 and many extensions have been built to house the growing numbers.

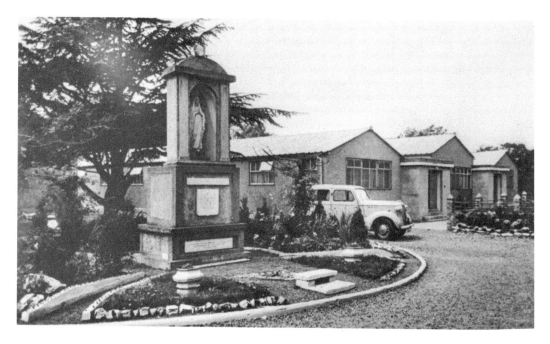

Laetare Youth Centre and Polish Memorial

Next to St Michael's Roman Catholic church, built in 1893, was the Laetare International Youth Centre, the brainchild of Father Michael McGovern. It opened in 1942 and later expanded into neighbouring buildings, which, during the Second World War, accommodated the Polish 1st Motor Ambulance Convoy. This unit, supplemented by women ambulance drivers from the First Aid Nursing Yeomanry (FANY), was in constant readiness to assist anticipated blitz casualties. On their departure, the Polish forces donated a memorial bearing the figure of the Virgin Mary. Laetare was demolished in 2007.

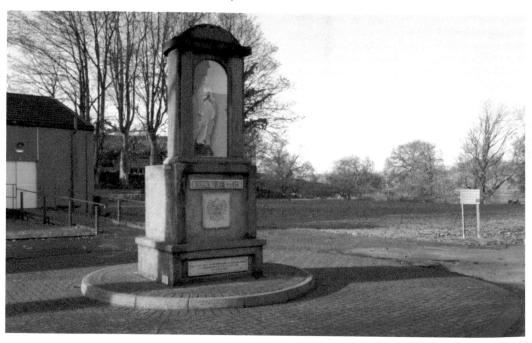

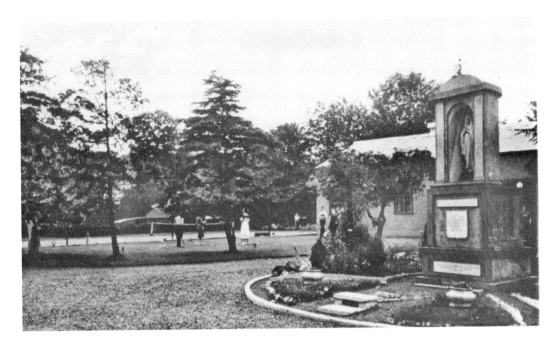

Laetare Tennis Courts

As an International Youth Centre, *Laetare* (Latin for rejoice) played host to thousands of youngsters from all over the world including disadvantaged children from Chernobyl and Bosnia. It also hosted many functions such as Christmas dinners, folk group concerts and twinning meetings. Father McGovern (parish priest 1940–80) oversaw continuing development in the area, including the construction of tennis courts and the Queen Margaret Hall, which has recently been extensively modernised. Sadly, the tennis courts have now gone.

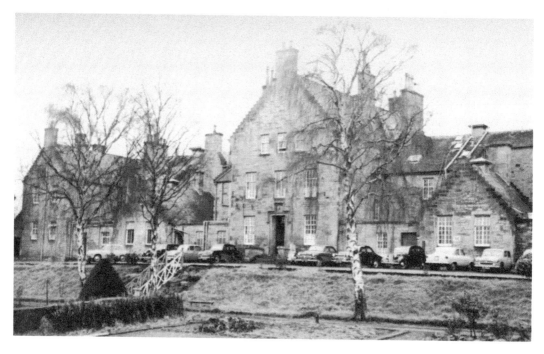

The Linlithgow Poor House

From 1856, the baronial building, which was the Linlithgow Combination Poor House, housed hundreds of the most unfortunate in society. On arrival, the inmate was stripped and bathed; men given a woollen, double-breasted jacket, a coarse-twilled, blue waistcoat, a striped cotton shirt, grey moleskin trousers and an indigo cap; and for women, a shapeless frock. Families were broken up and sleeping was communal, in bleak dormitories. Meals were strictly controlled and eaten in silence. The building was demolished in 1969. All now visible are the stairs from the front garden. Above it, to the right, is the Fever, now St Michael's Hospital.

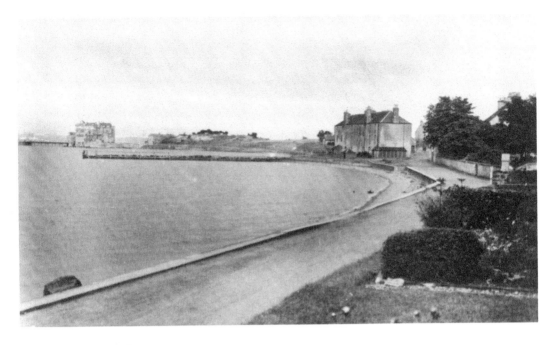

Blackness Castle

Linlithgow's harbour was situated at Blackness, some 2 miles away on the Firth of Forth. The village is dominated by its ship-shaped, fifteenth-century castle, which protected the haven. The village is inspected annually by Linlithgow's dignitaries during the Riding of the Marches and a Baron Bailie is appointed to safeguard ancient rights. Early references refer to boats simply being beached on the foreshore. However, in 1465, royal authorisation was given for the construction of a proper harbour. The site is now used by the local boat club utilising a 67-metre-long pier, first constructed in the 1960s.

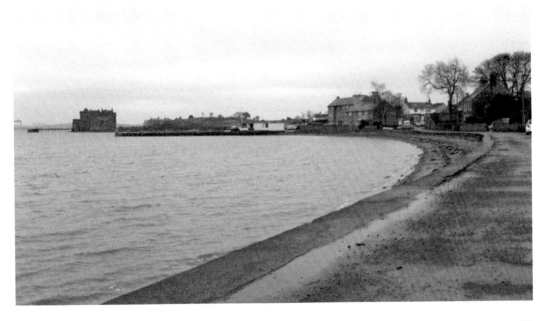

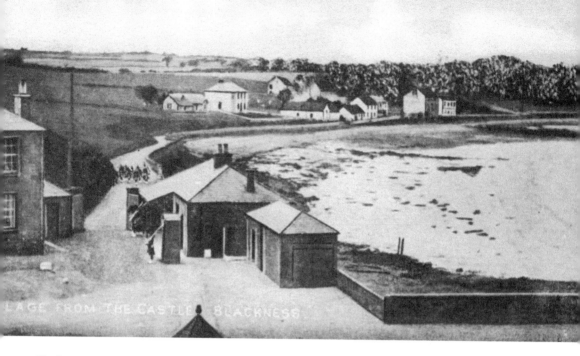

LAGE FROM THE CASTLE BLACKNESS

Blackness Bay

Looking from the castle, now managed by Historic Scotland, the town of Blackness stretches along the bay. The building on the right of the older view was the Guildry, a seventeenth-century building where officials controlled exports and imports. The building was offered to the National Trust in 1959, but the offer was declined and the building demolished, leaving behind only its name in a row of houses. Opposite, the small white-painted cottages have been replaced with a larger tenement called Nossirom Terrace (a reversal of the name Morrison).

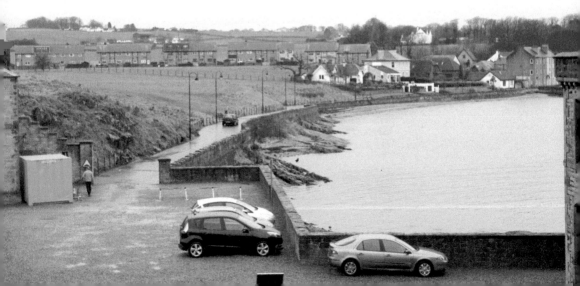

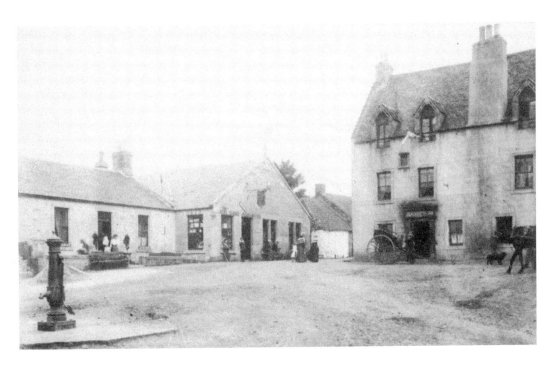

Blackness Village

The village pump has now been removed to one side of the square and two-storey buildings replace the seventeenth-century cottages. The village hostelry remains and is still called the Blackness Inn. Once a bustling trading town with thirty-six ships regularly plying to overseas destinations, it fell into decline once it lost its royal monopoly of trade when Bo'ness was given royal assent to construct a harbour with permission to charge unloading fees. Tax collection rights were transferred to Bo'ness in 1708 and the Blackness Custom House, and its associated harbour buildings, fell into disrepair.

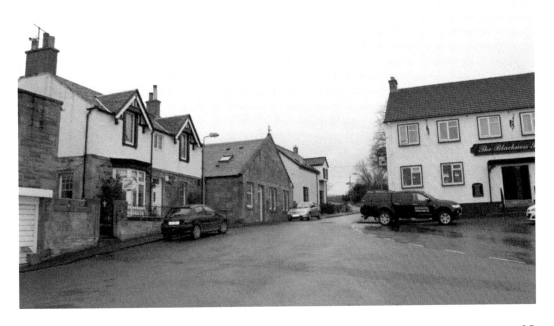

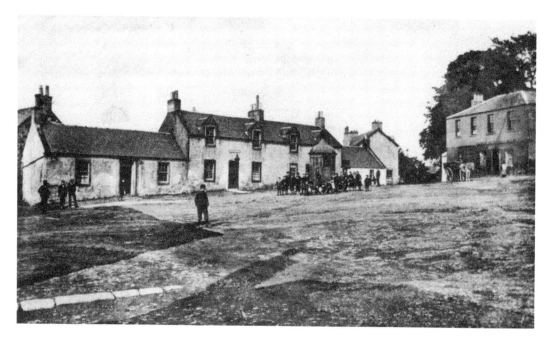

Torphichen

Another small village near Linlithgow is Torphichen: the name comes from the Gaelic for 'Hill of the Ravens'. Its church is said to have been founded by St Ninian around AD 400. In the twelfth century, the Knights Hospitallers of St John made the church or Preceptory their Scottish headquarters. Village life has always centred around the church and the village square, seen here. Today, although the post office and the inn are still the commercial hub, the village has expanded considerably into many other surrounding areas.

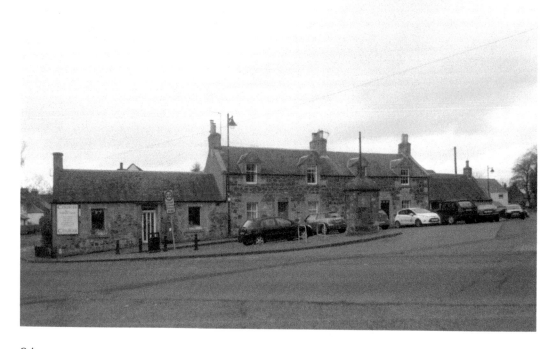

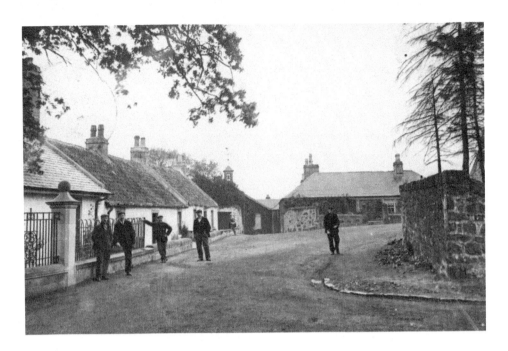

High Brae, Torphichen

To the south of the village, the original habitation expanded uphill into High Brae, Manse Road and St John's Place. The last mentioned streets take their names from the St John's United Free church, which was built in 1843 following the Disruption when the Revd William Hetherington and his congregation broke away from the Church of Scotland. The stone-built building still stands although it has lost the belfry, which can be seen in the older view. The building is now used as the hall for St John's church.

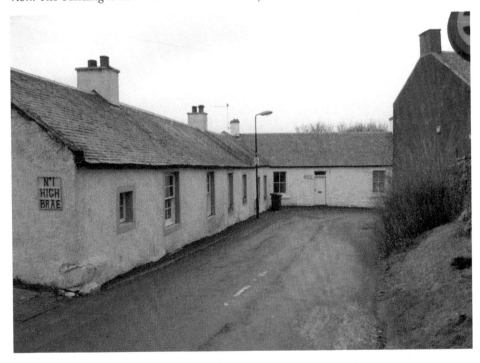

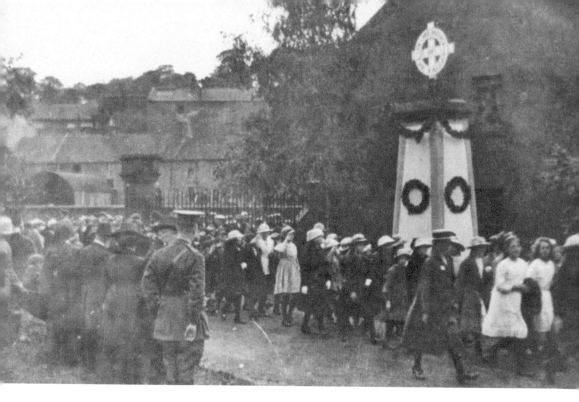

Back to the Low Port

The annual Riding of the Marches returns from Blackness and reforms at the Low Port before parading three times along the High Street and round the Cross Well. In 1920, a grimmer spectacle took place at the Low Port, when local schoolchildren paraded past a temporary war memorial, commemorating the 158 young men lost in the First World War. A more permanent memorial was unveiled within St Michael's church in 1921. Today, a new generation of young people parade through the gateway, on their way into Low Port Primary School or the Low Port residential and activity centre. The future of the thriving burgh is ensured.